REMEMBERING
YOUNGSTOWN

REMEMBERING
YOUNGSTOWN

Tales from the Mahoning Valley

EDITED BY MARK C. PEYKO

Charleston · London

THE
History
PRESS

Published by The History Press
Charleston, SC 29403
www.historypress.net

First published 2009

Manufactured in the United States

ISBN 978.1.59629.708.1

Library of Congress Cataloging-in-Publication Data

Remembering Youngstown : tales from the Mahoning Valley / edited by Mark C. Peyko.
p. cm.
ISBN 978-1-59629-708-1
1. Youngstown (Ohio)--History--Anecdotes. 2. Youngstown (Ohio)--Social life and
customs--Anecdotes. 3. Youngstown (Ohio)--Biography--Anecdotes. I. Peyko, Mark C.
F499.Y8R28 2009
977.1'39--dc22
2009012221

Notice: The information in this book is true and complete to the best of our knowledge. It is offered without guarantee on the part of the author or The History Press. The author and The History Press disclaim all liability in connection with the use of this book.

This book is dedicated to Ella F. Peyko and the family she loved.

CONTENTS

CONTENTS

Acknowledgements

I would like to thank the following people and organizations for their time, generosity and assistance in this project: the Mahoning Valley Historical Society; the Public Library of Youngstown and Mahoning County; Ron Flaviano; Historic Images; and Tom Molocea. In addition, I want to thank all of the writers who are featured in this book. Your talent and editorial contributions to the *Metro Monthly* are much appreciated.

INTRODUCTION

Whenever history and journalism are able to cross paths, it's a good thing. History gives perspective. It allows readers to better understand present-day situations and dilemmas. Even in breaking news, background history can give readers a critical depth of understanding.

However, history can mislead. It makes fools of us through its silence, by what has been willfully omitted in the dusty volumes of a research library. Because historical record is susceptible to misinterpretation and abuse, it is important to seek the truth. History is not always beautiful or comforting, but that's often what makes it worth exploring.

Despite these pitfalls, history remains one of the best ways to examine and interpret culture. This work features some of the best history articles that have appeared in the *Metro Monthly* since its inception. As publisher, I have chosen articles that reflect a broad range of subject matter. Although this book does not cover the total history of the Mahoning Valley, it does include some of the more interesting aspects of Youngstown history. In addition, I think it also accurately reflects the consistently broad and varied interests of the *Metro Monthly*.

Youngstown, Ohio, is rich in history. Due to its ethnicity and diverse culture, the town is a much bigger city than its present-day population numbers would suggest. To the casual observer, Youngstown may appear to be a series of interconnected urban legends and exaggerations, but if you work in the media long enough you'll find out that many of these stories are true. What happens in Vegas may stay in Vegas, but what happens in Youngstown is told for generations.

Youngstown is filled with great storytellers. I hope this volume lives up to that well-respected tradition.

PART I

SETTLEMENT AND GROWTH IN THE MAHONING VALLEY

CHURCH CONGREGATIONS PROVIDE GLIMPSES INTO ETHNIC LEGACIES OF YOUNGSTOWN NEIGHBORHOODS

Rebecca Rogers

Almost all early settlers of the Mahoning Valley came west from Pennsylvania, New York and New England.

Early settlers worked in agriculture, but by the mid- to late nineteenth century, a growing industrial economy soon attracted emigrants from northern, central and eastern Europe.

Recent research has determined that many of the settlers of the pioneer period and farm-dependent economy of northeastern Ohio did not have enough money to buy land or enough training to be journeymen or masters of a trade.

Like subsequent urban European and African American immigrants, early settlers often left little personal history or record of their lives here. Instead, the strongest legacy of each immigrant group had been the church congregations that were often located at the center of the community or ethnic neighborhood.

As the village economy of Youngstown began to grow rapidly following a national depression in the late 1830s, the climate for the assimilation of an immigrant population improved. New settlers came to the Mahoning Valley when the crosscut Pennsylvania Canal, which connected New Castle, Pennsylvania, to Akron, Ohio, was started. The canal provided opportunity for laborers, especially stonemasons, and workers who drove horse teams [draymen].

The forecast of prosperity encouraged many merchants, financiers and goods manufacturers, who saw the opportunity of a reliable transportation system, making Youngstown a boomtown.

Shortly after the opening of the canal in 1840, coal was discovered near the Brier Hill farm of David Tod. The nascent industry attracted coal miners to the Mahoning Valley and Youngstown. Canal construction and mining attracted rural and European immigrants, with the largest number of foreign-born workers being Welsh and Irish. Both ethnic groups settled near Brier Hill.

The presence of these immigrant groups is evident in the churches that they established, many dating from the 1840s. St. Columba's Catholic Church was established around 1840. The parish grew from earlier missions that met east of Brier Hill and on Youngstown's East Side. In the village of Brier Hill, a Welsh Congregational Church was formed around 1840 and a Welsh Presbyterian Church was established soon after.

East of Brier Hill and south of the main road to Warren, Ohio, a worker neighborhood known as the Caldwell District grew in the floodplain of the Mahoning River. This area, like Brier Hill, had a mix of ever-changing immigrant residents. The Caldwell District provided labor for the Eagle, Cartwright and McCurdy furnaces.

In Youngstown, the south side of the Mahoning River attracted immigrants somewhat later—in the 1850s and 1860s—following the construction of the Phoenix and Falcon blast furnaces on the north bank. Irish immigrants settled along Poland Avenue and Flint Hill Street [South Avenue] across the Presque Isle [South Avenue] Bridge. The area quickly became so predominantly Irish American that it was locally known as "Kilkenny." St. Columba's founded a mission and a parochial school there on Franklin Avenue.

Farther west—from the bluff on the south bank of the Mahoning River to Mill Creek—along Mahoning Avenue, German immigrants established a neighborhood. They organized Lutheran meetings above the south riverbank, near present-day Warren Avenue, in the mid-1850s. In 1859, German Lutherans organized Martin Luther Church and built a house of worship on East Wood and Champion Streets in 1862. The Mannerchor [a German men's choir] was established in the early 1860s and hosted picnics and songfests near the bluff. Germans settling in Brier Hill established St. Joseph's Catholic Church on Rayen Avenue in 1870, and St. Paul's Evangelical Lutheran Church was founded in 1881. It's interesting to note that Brier Hill and the neighborhood west of lower Belmont Avenue had many streets with German names, some of which were renamed during World War I.

German Jews began coming to Youngstown in the 1830s and settled mostly on the east side of Brier Hill in an area called "West Youngstown," near the Westlake Crossing. After first meeting in private homes, immigrant Jews organized the Rodof Sholom congregation in 1867 and built a temple at Lincoln and Fifth Avenues in 1886.

African Americans, some of them craftsmen [most notably masons], settled on the South Side, building a Baptist church on Mahoning Avenue and Oak Hill Avenue Church [AME] on Oak Hill Avenue.

By 1870, Youngstown was accepting immigrants from rural areas and Europe. The Welsh continued to come to the small hamlets clustered around the coal mines that opened during the boom days of the early 1870s. The Scots, mostly coal miners, settled in Lansingville and left the legacy of Caledonia and Campbell Streets. In Brier Hill, Catholics, mostly of Irish descent, founded St. Ann's Catholic Church.

In the 1870s and 1880s, Irish immigrants settled near a coal mine on the South Side of Youngstown on present-day Ridge Avenue [called The

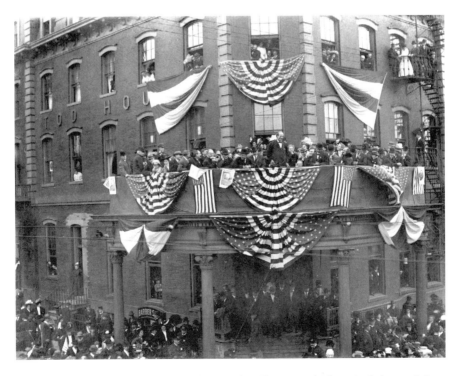

Democratic presidential candidate William Jennings Bryan speaks from the balcony of the Tod Hotel in 1896. The hotel was built by P. Ross Berry. *Courtesy of Historic Images.*

Blocks]. On the East Side, the Irish established Immaculate Conception Church and School in 1881. The Irish lived on the east bank of Crab Creek, just north of Oak Street [called Bottle Hill], near a rolling mill and Daniel Shehy's farm on Shehy Street and Wilson Avenue [known as Vinegar Hill]. The neighborhood was adjacent to the Himrod Furnace. Irish Americans at Haselton, near the canal and the Andrews and Hitchcock blast furnaces and rolling mill, founded Sacred Heart Catholic Church in 1888.

Late in the 1870s and during the 1880s, immigrants who did not speak English as their primary language came to Youngstown to supply the ever-expanding need for workers. Italians, Hungarians, Scandinavians and Slovaks followed the Irish, Welsh and Germans into the Caldwell District, taking over the older housing stock and seeking out those who spoke the same language. Italians settled south of the river near Mahoning Avenue among the Germans.

The Scandinavians—mostly Swedes—settled near Kilkenny and Haselton. A Swedish mission was founded on Poland Avenue in Kilkenny in 1886, and another Swedish church was founded in Brier Hill in 1890. Bethel Lutheran, a Swedish congregation founded in 1881, constructed a church in 1890 on Wilson Avenue in Haselton.

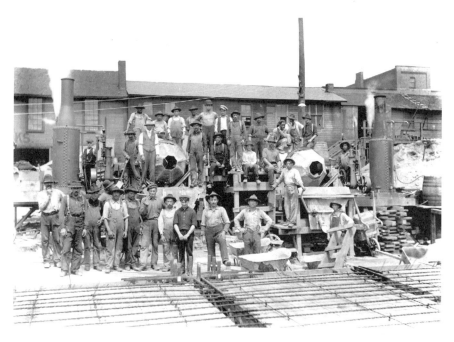

This photograph from the John D. Megown Collection depicts immigrant laborers at a turn-of-the-century concrete project. *Courtesy of Historic Images.*

Tales from the Mahoning Valley

Most early Slovak immigrants lived in a worker neighborhood at the east end of Federal Street, near Basin Street at the junction of Crab Creek and the Mahoning River. Slovaks founded St. Cyril and Methodius Catholic Church on Wood Street in 1896. The church became parent to many eastern European churches in the Mahoning Valley.

As the 1890s began, Youngstown's ethnic neighborhoods grew dense and ready to burst into new areas within walking distance of the new industries. As earlier immigrants to Youngstown became more prosperous, the worker neighborhoods began to expand away from the floodplain, up the nearest creek or riverbank.

The working-class neighborhood near Federal and Basin Streets spread north along Crab Creek, past Rayen Avenue and into the small valley that became known as Smoky Hollow. Like Brier Hill and the Caldwell District, Smoky Hollow was populated by residents of many different ethnic origins.

Plats of new streets began in the 1870s near Rayen Avenue. Ethnic groups established their churches along Rayen or Wood Street. In the 1890s, Haselton expanded up the north riverbank, moving west toward Youngstown. At the same time, Lansingville expanded east and west along the south riverbank.

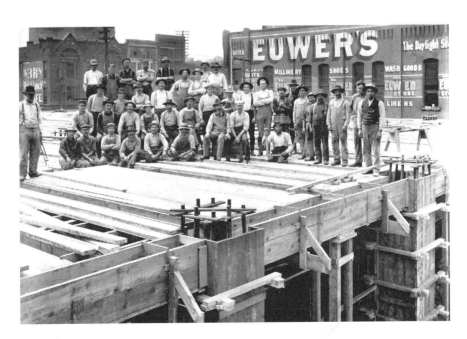

Workers pose after setting up the concrete framework for a new building in downtown Youngstown. Euwer's Daylight Store is seen in the background. *Courtesy of Historic Images.*

The Ohio Works, Youngstown's first steel producing mill, was planned in the early 1890s on the west side of the Mahoning River floodplain. Across the Mahoning from Brier Hill and the Caldwell District, the West Side attracted new immigrants who lived at Brier Hill, the Caldwell District and Mahoning Avenue.

New West Side ethnic neighborhoods grew along Salt Springs Road and Waverley Street. Often the newest European immigrants working at the Ohio Works were from the south and east of Europe: Slovaks, Carpatho-Russians, Ukrainians, Croatians and Serbs. Settling in the oldest worker neighborhoods, they saved to build churches precious to their ethnic heritage.

Carpatho-Russians, who adhered to the Byzantine Rite, founded Assumption of the Blessed Virgin Mary on Florence at Salt Springs Road in 1900. It was the sponsoring church for Byzantine Rite congregations in the Mahoning Valley, including St. Nicholas in Haselton [1912].

Ukrainians were involved in the organization of Holy Trinity Ukranian Catholic Church [1909] on West Rayen, and Croatians who were Roman Catholic organized Sts. Peter and Paul on the north side of the river in 1910.

Serbians who were Orthodox organized Holy Trinity Serbian Orthodox Church on the West Side, buying land for a building in 1929. Poles, Romanians, Transylvanians, Lithuanians, Lebanese and Russians joined them in the neighborhood.

Austrian Poles settled in Kilkenny along South Avenue, founding St. Stanislaus. Russian Poles gravitated to the east side of Brier Hill, where they started St. Casimir. Romanians lived on the lower East Side, founding St. Mary's on Prospect Street and Holy Trinity on Wilson Avenue. The German-speaking Transylvanians, who mostly attended Lutheran churches, founded the Saxon Club on South Avenue in 1907.

Lithuanians settled near the Romanians and Hungarians on the lower East Side, founding St. Francis of Assisi on Shehy Street in 1918. Lebanese Maronite Christians, who mostly lived near the east end of Federal Street, founded St. Maron Church at the beginning of the century.

Russians were a large enough ethnic group to start Nativity of Christ Russian Orthodox Church on West Arlington in 1915. Russian and Polish Jews established an Orthodox temple, Children of Israel, near Smoky Hollow on Summit Avenue.

The greatest European ethnic growth arrived in the decade from 1900 to 1910. Many of these people settled in the oldest ethnic areas of the city: Brier Hill east to Belmont Avenue; the Caldwell District, along Mahoning Avenue; lower South Avenue and Poland Avenue; and Haselton.

Others sought out the newer areas adjacent to the newest blast furnaces, rolling mills and steel plants. The greatest mill construction occurred near Haselton and Lansingville at the Youngstown Sheet and Tube and Republic sites, near Market Street and the Mahoning River at the Republic site and along the Mahoning River from south of Girard, including the Ohio Works. Established ethnic communities responded to the opening of the Market Street Viaduct [in 1899] with a rush of new construction at the top of the riverbank on the South Side.

Italians, Hungarians, Scandinavians and Slovaks continued to immigrate to Youngstown at the turn of the century. East Side Italian Americans organized Our Lady of Mount Carmel in 1906, building the present church in 1913. Italian immigrants who worked at Brier Hill or at the Ohio Works founded St. Anthony of Padua in 1898.

In 1904, Hungarian Protestants organized and built a stylish limestone building, the Magyar Evangelical Reformed Church, under the sponsorship

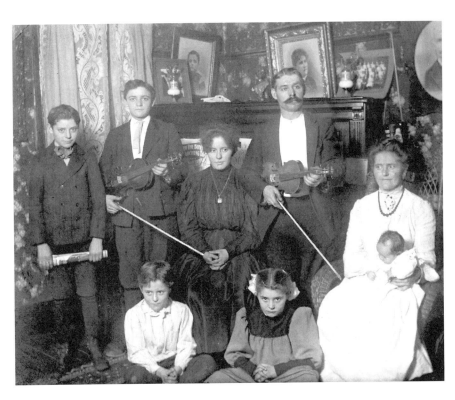

The Hugh Dixon family of Park Hill Drive in Youngstown. *Courtesy of Historic Images.*

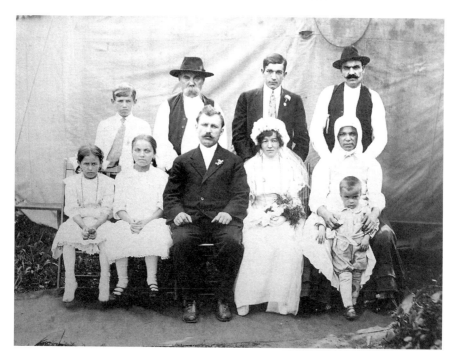

Hungarian immigrants Stephen and Bertha Fenyo after their wedding ceremony in Niles. *Courtesy of Irma Lefter.*

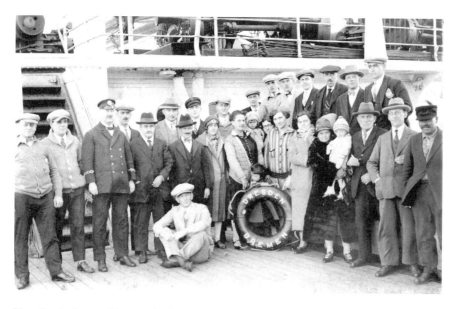

Traveling by boat to Hungary in the late 1920s. The woman and child in the photo postcard are Ilona Peyko and William S. Peyko of Campbell. *Courtesy of Mark C. Peyko.*

of First Presbyterian Church. It was the first solely ethnic Hungarian congregation. On the lower East Side, St. Stephen of Hungary was organized to serve Hungarians from neighborhoods near East Federal Street and lower Himrod Avenue.

Greeks, who had dispersed throughout the city, organized a church in Brier Hill and then built St. John Greek Orthodox on Woodland Avenue in 1904.

Scandinavians moved from Haselton and Kilkenny, establishing an ethnic neighborhood that stretched from Woodland Avenue south and east to Southside Park. Near Woodland Avenue were three Lutheran churches as Bethel Lutheran moved from Haselton to Ridge Avenue.

Slovaks—Youngstown's largest European ethnic group—settled at Lansingville, the West Side and Haselton. They established three Catholic churches, St. Matthias [1913], Holy Name [1917] and St. Elizabeth [1917], and at least two protestant churches, one on the West Side and the other in Lansingville.

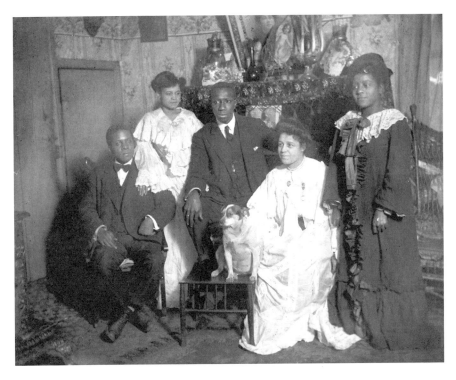

The Clark family of 329 West Federal Street in Youngstown in 1907. *Courtesy of Historic Images.*

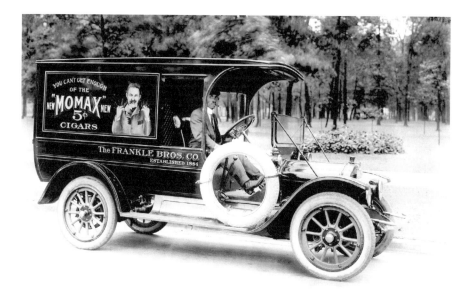

A driver for the Frankle Bros. Company in Youngstown. Wick Park is seen in the background. *Courtesy of Historic Images.*

Although World War I slowed growth, it did not abate the need for workers.

The virtual closing of foreign immigration after the war did not slow the demand for people to work in Youngstown's industries. The greatest group of immigrants coming to the city in those decades was made up of African Americans moving north from southern Ohio and the American South. Once again, the oldest housing accepted the newest immigrants. Youngstown's African American population rose 250 percent between 1910 and 1920, with most of it coming in the last two years of the decade. African Americans settled on the South Side, on the East Side and in Smoky Hollow, but the largest neighborhood was near an African American commercial area on West Federal Street, near North Avenue and Covington Street.

By 1930, Youngstown's population was 54 percent of foreign birth or extraction. However, this date also marks the end of dramatic population growth. In 1930, one in ten workers in Youngstown was out of work, and the rosters of unemployed grew dramatically in the following two years. Between 1930 and 1940, Youngstown's population did not increase. The city's greatest population, 170,000, was recorded in the 1930 census.

EASTERN SPECULATORS SAW POTENTIAL IN HINTERLANDS OF WESTERN RESERVE

Rebecca Dale

There was a wonderful sled-riding hill on the Austintown farm where I grew up. From the top, you could see for several miles. Indians roamed there just a few generations earlier, and my dad often turned up arrowheads and other artifacts from that field. He was the last farmer to do so.

Today the site is covered by residential streets and suburban subdivisions, and the construction of homes and businesses continues everywhere, especially in the rapidly growing townships of Austintown, Canfield, Boardman and Poland.

It's tempting to think of development fever as a recent trend, but a quick glance at local history shows that area real estate has been a hot investment ever since 1795 when the Connecticut Land Company started promoting the Western Reserve.

Two hundred years ago, these buyers purchased thousands of acres at a time, often sight unseen. The histories of some of the Mahoning Valley's largest and oldest townships appear below.

Austintown Township—Eliphalet Austin was one of the original stockholders of the Connecticut Land Company. In addition, he was the land agent who did the actual selling for two other stockholders, Gideon Grange Jr. and Oliver Phelps, who originally held the title to what is now Austintown Township. Austin himself bought land in Ashtabula County, where another community named for him, Austinberg, is located.

In 1798, John McCollum of New Jersey became the first to settle in the township and set about clearing the land and farming it. Others soon followed, and the vast majority of these early families were farmers.

James and Benjamin Sisco were among the very few black pioneers in the Western Reserve, settling in the southwest section of Austintown Township.

In 1835, farmer Michael Ohl discovered a vein of coal on his property. By mid-century, there were more than ten separate coal mines operating in the township, and by 1880 nearly four hundred men were employed in mining. Austintown Center was growing, with a post office and general stores to serve the needs of an expanding population.

A county tuberculosis sanitarium was built on Kirk Road in 1924. With its own nurses' residence, farm and public school teacher, it stood for fifty-eight

years, until modern medicine made that kind of long-term care—often up to four years at a time—unnecessary.

Austintown's population doubled in a single decade between 1940 and 1950, making it necessary to build four elementary schools in three years in the mid-1950s. Since then, the township has grown steadily into the suburban community it is today.

Canfield Township—Originally called Campfield, this township was renamed for Judson Canfield, the largest landowner of six men who first bought large tracts of property in "Township Three, Range One." The price the men paid for this land came to about seventy-nine cents per acre.

Champion Minor was Canfield's first settler. He brought his wife and children here from Connecticut in 1798. One child soon died, and the remaining Minors, along with two surveyors, spent that first winter alone in the center of Canfield. The next year more settlers came, and ten years later Canfield was a thriving frontier community. Although farming was the basic activity, Canfield very early became a center for trade.

In 1846, when Mahoning County was created from the ten southern townships of Trumbull County and the five northern townships of Columbiana County, Canfield became the county seat. A courthouse was built on the south end of the Green in the same Greek Revival style that dominated most of Canfield's homes and other public buildings of the time.

In 1876, court records were moved to the newly designated county seat in Youngstown, where most of the county's growth and change was occurring. Canfield citizens were bitter over the loss. Because of it, their community remained a quiet agricultural center for a long time, probably resulting in much of its original architecture remaining intact. The Mahoning County Agricultural Society was formed in Canfield in 1847, and the first Canfield Fair was held on the Green that year. No rides or cotton candy. Just prizes for good cattle and fine quilting.

Boardman Township—Elijah Boardman came from Connecticut in 1798 as part of a surveying party and stayed on as the first settler. The next year, the township had three families, and by 1810 was one of the most populated in the Western Reserve.

Most of the early residents were farmers, and many of the farms had sugar camps for making maple syrup. The southern part of the township had a stand of timber that was considered one of the finest in the state, containing much wild game. It was eventually destroyed by fire, but the present Boardman Woods is a reminder of that heritage.

Tales from the Mahoning Valley

By 1903, the center of Boardman Township was called "Oakland," and there was a campaign to develop it and sell lots for houses. A brochure of the day promised that it was only fifteen minutes from Youngstown's Central Square via the Youngstown and Southern Railway, a trip that was said to be as beautiful as an excursion through Switzerland!

Those same railroad cars brought families out to the Southern Park Race Track at McClurg Road and Southern Boulevard. This sports complex featured thoroughbred and greyhound racing, with a grandstand and baseball fields north of the track and tennis courts and a picnic grounds, as well.

Boardman Plaza was built in 1950 in the midst of a cornfield and a swamp. It featured sixteen shops and free parking. Many thought that no would want to drive so far into the country to shop. They were wrong. The 1960s brought a new wave of residential development to Boardman along with the Southern Park Mall.

Poland Township—Turhand Kirtland was another agent for the Connecticut Land Company who came to plat and take claim to western land in 1798. He laid out a town on Yellow Creek and, in order to encourage development, gave a portion of it to be used for a school, a church and a graveyard.

His brother-in-law, Jonathan Fowler, arrived the following year to take up residence as the first settler. The township and village [first called "Fowler"] were later named Poland to honor the Polish heroes who came to help fight for American independence.

Many crafts and industries flourished in early Poland Township. The "Poland Furnace" was the first iron blast furnace in the Western Reserve, and a sawmill and a gristmill were located on Yellow Creek. Sheep were a major source of income for local farmers, and between 1860 and 1880 Poland was an important wool-packing center. The cattle business also thrived, and both sheep and cattle were frequently driven through the village on their way to Pittsburgh.

The Kirkland Ink Company was another local industry. Chemist George Kirtland invented the special formula, and his business flourished until the Civil War. Another unusual industry was a broom factory. The owner, Hugh Cover, raised the broom corn on his Poland Township farm.

President William McKinley [1843–1901] grew up in Poland, having moved from Niles, Ohio, at age nine so he could attend Poland Union Seminary. Ida Tarbell, the "muckraking" political writer of the early twentieth century, was another famous Poland resident. She taught at the seminary for several years.

No discussion of Poland, however brief, would be complete without mention of its municipal forest, the first of its kind in Ohio. Grace Butler donated the original 212 acres, and many visitors come each spring to see its display of bluebells.

THE ENDURING LEGACY OF THE RAYEN SCHOOL

John Patrick Gatta

After the end of the 2007 academic year, Rayen ceased to be a city high school. Its memory lingers, however, with many former students who recall how the North Side institution prepared them for life—in and outside of the classroom.

For many, the Rayen School was revered for its academic excellence and as an institution that prepared students for higher education. "A high school of the caliber of Rayen, in the early twentieth century is equivalent to a college education today," said Bill Lawson, director of the Mahoning Valley Historical Society. "It was an academy of higher education that the community was very proud of."

"Rayen had a great tradition as the first high school in town," said Reid Schmutz, a 1960 Rayen graduate. Schmutz is a trustee for both the Rayen Foundation and Youngstown Foundation. "You always had a lot to live up to," he said. "There were a lot of great alumni in town, a lot of role models that you had to live up to. Being a Rayen graduate, it put a little pressure on you to excel and not blemish the name of the school and follow in the steps of those who came before you."

Because of Rayen's high academic standards and success rate, which saw graduates moving on into top colleges, the school attracted students from other parts of the state. "The curriculum was widely recognized. People came from all over the Western Reserve Territory," said former Rayen principal Henrietta Williams. The Western Reserve encompassed the northeast area of Ohio, including Cleveland, Chardon, Hudson, Medina and surrounding communities.

A trust from the estate of Judge William Rayen created and funded the school and provided an endowment for scholarships. The Rayen School opened in 1866 and did not exclude due to race, creed, gender or color. Although many of its early students were from affluent families, young men and women had to demonstrate academic success.

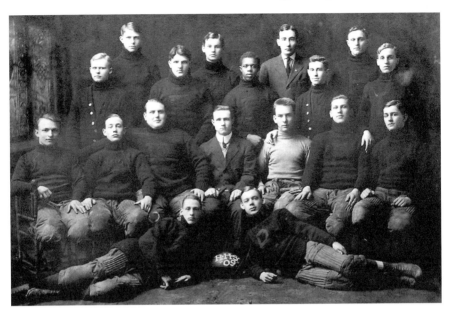

The 1909 football team at the Rayen School in Youngstown. *Courtesy of Fran Lynn Into.*

"It was always a public high school but [academic] exclusivity made it like a prep school," said Lawson. "No one was there to fool around. If you were disruptive, you were out. That gave Rayen a high quality of student body and of academic achievement. For wealthy kids, it was part of their finishing before they went off to college," he said.

Lawson pointed out that most young people at that time only went as far as eighth grade. Then they moved on to life working in steel mills or other occupations. "After World War I, and more so after the Great Depression, we see that there was a call for mandatory high school," he said.

Williams credited Judge Rayen for his vision. "He was beyond his years," she said. "It was for all children. It was not meant to be elitist. That was Rayen's desire. It just so happened that when the teachers sat down, they patterned it after Harvard and top schools in the country…So, it was impressive when you came out of Rayen. Those schools would recognize and accept you," Williams added.

Lawson said the Rayen School reached its pinnacle in the early twentieth century, due to its faculty and academic standards. "You must remember that Youngstown was a very dynamic and affluent city during that period." He compared turn-of-the-century Youngstown to the Silicon Valley of today, due to its robust industries and technological innovations.

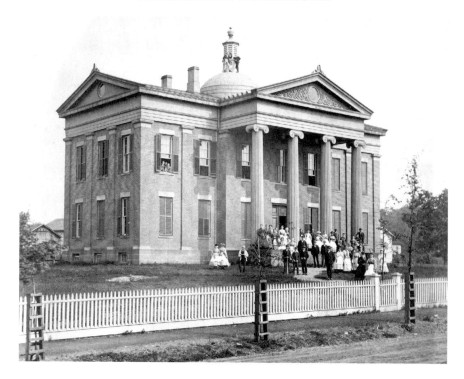

The first graduates of the Rayen School in 1866. The Rayen School was built by P. Ross Berry. *Courtesy of Historic Images.*

"Rayen followed the fortunes of the city, which have not been so good in the last thirty to forty years," Lawson said.

Suburban population shifts affected enrollment and the money to support the schools. Lawson mentioned that such financial issues have created a degree of difficulty for Rayen's more recent students to compete with the school's lauded past. "There's still a strong tradition in Rayen," Lawson said. "It comes to the surface with alumni, students and faculty. Tradition is still there, pride is still there, there are still academic achievements. Still it graduates kids who go on to top universities, who excel academically and athletically."

Schmutz recalled the dedication of Rayen faculty. "During my senior year, every teacher one or both of my parents had too. They were a dedicated and experienced faculty."

Schmutz said he most remembers the diversity of the student population: "A great melting pot—children of steelworkers, first-generation immigrants, a mix of where people lived—the North Side of Youngstown—which went all the way down to the projects to those in Liberty who paid tuition. It was a good of mix of kids."

YOUNGSTOWNER'S 1950 MANUSCRIPT BRINGS BRIER HILL'S ITALIAN COMMUNITY TO LIFE

John B. Severino

The following memoir of life in Brier Hill in the first half of the twentieth century was provided by the family of its author, the late John B. Severino. Severino was born in 1911 in Youngstown, one of six children of Vincent and Elvera Arcomano Severino. He married Cecilia Theodore in 1931 and lived with her and their two children on Dearborn Street until 1948, when the family moved to the West Side of Youngstown. Severino worked at the General Fireproofing Company. John B. Severino died in 1960.

Leaving the Old Country—My father, Vincent Benedetto Severino, was born in Italy. His life was one of continual hard labor, few conveniences, and no luxuries to speak of. My grandmother used to tell us that when Pa was only 2 or 3 years old he accompanied her to the fields, where he gathered sticks, pulled weeds, picked up acorns, which were used to feed hogs, and later he picked cotton, olives, and figs. The land was very mountainous, and they could sustain themselves only by dint of untold hard labor, patience and knowledge of plants and trees.

My father's father was Domenico Severino, and he came to America about 1895. His father originally came from the province of Calabria, at the very tip of the Italian "Boot." My father's mother, Felice Marsico, was of an ancient Italian family and there are many branches of it in this country. Grandma Marsico came from a well-to-do family, having lots of olive trees and land. She had several uncles who were priests and monks.

My mother was born about 10 miles from my father's village, but in her days, 10 miles may as well have been a thousand. She never left her birthplace, not even to go to a neighboring village, until she got married. She was the second of six children of Antonio and Philomena Giurato Arcomano.

She and my father never saw each other until a few weeks before they were wed. That was the "old time" way of marrying. "The elders" decided whom a certain girl would marry, and she did so—no questions asked. Sometimes girls and boys were promised to each other upon being born or even before.

My dad was 33 years old when he left America, where he had been working, to return to Italy to get married. He had left workers building a new house for him to move into when he got back.

Upon arriving in Italy, he settled various affairs for his father, who was here in America, and then started looking around for a wife. He asked his

relatives if they knew of any girl. They told him of the Arcomano family having a girl of marrying age, so he went to Rocconova (which means "New Rock") and inquired.

Ma says he looked so huge and handsome, and had on a coat that reached almost to his heels the first time she saw him. He was about 5'8", but in later years, from incessant hard labor, he was sort of stooped, but I'm sure he was a fine looking man when Ma first saw him. She was about 17 years old then. They were married soon and came to America immediately.

The early years—The house we lived in on West Federal Street had two rooms upstairs, two downstairs and a cellar. No gas, no furnace, no electricity. We had water at the sink, but generally used pump water to save money.

We lived in the cellar of our home, where the cook stove was, and then upstairs there was a dining room and a living room where the principal occupant was a large leather couch. There was a pot-bellied

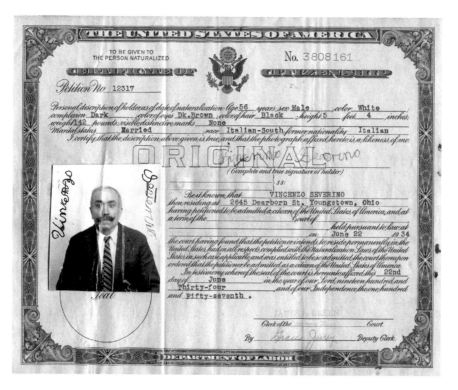

The citizenship certificate of Brier Hill resident Vincenzo Severino. Severino and his family lived at 2645 Dearborn Street in Youngstown. *Courtesy of Vincent Severino.*

stove upstairs for heat, but none in the two bedrooms, one for my parents and one for Grandpa.

When I started Tod Elementary School on Robinwood Avenue I hardly knew any English because Ma and Pa and Grandma always spoke Italian, so I learned the language thoroughly.

I can remember running home from school, down Robinwood Avenue and waiting at Federal for Ma to cross over and get me. There were horses and streetcars to watch out for, and occasionally a car or truck, usually with a chain drive, which clanked and rattled very fearfully.

I used to love to run down the long hill and look over my shoulder at the sun, and it always seemed to be running right along with me. Sometimes, at the corner of Robinwood and Federal, in the empty field, I'd pick daisies or mayflowers for my mother. We also used to go there to pick chamomile, an herb used for tea.

Childhood escapades—One time, my sister Florence and I had a small rake-and-hoe set, and we got to fighting over them so I hit her on the head with the hoe. My Grandpa came running up and gave me a spanking, so I hit him on the knee with the hoe, earning for myself another spanking.

When I was about 5 years old, I remember vividly an escapade. We had outside toilets, and ours was lined with cardboard on the inside. One day I removed a section of cardboard and stuffed the inside with papers, and started a magnificent fire. Result: one magnificent licking.

Once, in the fall of the year, Pa had grown a huge pumpkin and had it on the ground, at the top of the hill in our yard, ready to put it in a wheelbarrow. I was told not to touch it, so of course I fooled around till it started to roll downhill and smashed against the fence. I do not remember if I got a good hiding or not, but if Pa was up to snuff, I'll bet he swore for five minutes without stopping. On occasion, he could, and did, mention every saint ever canonized by their full name, and if mad enough, he would go all over them to make sure he hadn't missed any.

Putting food on the table—The garden was always a thorn in my adolescent side. I used to accompany Pa there. We had to walk down the path, cross the street to the nearest house where Pa's cousin, Mr. Marsico lived. He had a pump there where we pumped out water and carried it back up to the garden.

I would put about one-half a can of water on each plant and pretty soon, Pa would spy me and would say "put more water," and then he'd grab the bucket and show me how—four tomato plants to the bucket—and he planted

hundreds of them. I think he had a special variety of tomato, crossed with sponges, and he invented them to torment me.

Another thing we had was an outside oven. My Dad liked old-fashioned homemade bread—and so did we. We had very little store bread, and when we did get store bread, we thought it was cake. Besides, if you have six kids, you need at least three loaves of bread per meal the way we used to eat it with our beans and soup and greens.

The oven was made of stone and brick and needed lots of wood to heat it up. You could cook about two dozen loaves at once, besides pizza by the dozen. I have mixed many a batch of bread for my mother—about half a sack (a big 94-pound sack) in a great tub with just salt, water and yeast—no sugar or milk or shortening and 47 vitamins like they advertise now.

When the dough was formed into loaves, my mother would put the loaves into the oven with a long-handled wooden shovel. She would put the iron door in place, and, with a last look, check if the draft holes were just right. She would go away, and when she came back, the bread was baked—a huge basket full of large loaves, enough to last us kids about six or seven days.

When I was eight or nine years old, my father sold the house on Federal Street. The old Brier Hill Steel bought up the land, and it was upon this spot that the [Youngstown] Sheet & Tube Company built its large office building.

Earning a living—In the Sheet & Tube mill, Pa and my uncles and all the neighboring men worked—for less than a dollar a day and with which they raised families and bought their little homes with—and not eight hours a day, but 12.

In making steel, the blast furnace has to be charged with ore, limestone, coke, etc., and it is filled from the top by small cars on trolleys that go up an incline and dump into the top of the furnace.

Forty or 50 years ago [in the early 1900s], men pulled two-wheeled cars up a ramp and dumped the contents into the furnace. Later the ramp was replaced with a crude elevator—no sides or top, just a moving platform called a "cage," which lifted the loads of material, along with the men. This was hard, hot, dirty work.

As I said, Pa sold the house and bought the one on Dearborn Street for $4,200—a tremendous sum in those days. Pa sold our old house for a good profit, so he purchased two lots on West Federal Street near Stop 7, which he used as gardens.

(This is where my education continued in the delicate art of supplying thirsty tomatoes with huge quantities of water, pumped by hand out of an old-fashioned pump and carried by bucket. What a trip back and forth! What

muscles! What screaming in both English and Italian when a hapless tomato got in the way of my clumsy foot, or the hoe—or any of a dozen ways that tender plants can choose to die on you in spite of how you pamper them!)

Early work years—Uncle Patsy had started in the contracting business, building houses. So I got a job with him. The first job that I had with him was taking his lunch to him, on a house he was building on Dearborn Street near Girard. I used to take him a little basket full of sandwiches, pepper, eggs, etc., and I always got my share.

The house he was working on was brick, so I used to smooth off the cement between the bricks with a smooth iron rod. I was about 11 years old. From this work he went to house painting and repairing, and hired men to work for him. Among other houses he erected is the little house we lived in so long ago on Dearborn.

That is where I got a bad cut on my wrist with a hatchet. One day, the carpenter told me to cut the wire on the shingle bundle with a hatchet, and the blade slipped on the wire and cut my unsuspecting wrist. Result: doctor's visit.

The first summer I worked for Uncle Patsy did not prove very profitable. I remember very well, as though it were yesterday, as we were walking home very late one night, that he told me how good a job I'd have and the many things I'd learn. In the end, I received for the summer's work 50 cents. Yes, 50 cents.

Another time, I was apprenticed to a tailor. So my duties were to be downtown at 8 a.m., light the gas stove, put on the irons—they weighed about 8 or 10 pounds each—maybe more. The head tailor was my brother Dom's godfather. There were three other tailors there, and on slow afternoons, they'd give me a dime to go to the movies while they gambled. I generally used to spend a nickel of it for an ice cream cone and the other nickel for another cone to be eaten on the way home. Oh yes, I walked to town and back every day. The pay for sweeping, sewing on buttons, keeping the irons hot? NO pay! I was learning a trade and no pay was expected.

This "job" only appealed to me for one summer vacation, and I went with a building contractor the following year. He built lots of homes on the West Side, right near where we now live (North Maryland Avenue), and I learned some carpentry.

Horseplay—In those early carpentry jobs, I also got a wicked eye for throwing nails at horses. The sand, cement, all the lumber, plaster, etc., was delivered by horse and wagon and I just loved to hide up on the top floor of a new house and throw nails onto the horses' rumps, causing them

to jump and quiver, and all they got for their pains was cursing or hollering by the driver.

One day I was being chased by another apprentice on the second floor of a house that was just being built. Only the framework was up. I fell through the floor joists all the way down into the basement onto a pile of sand. I never even got a scratch!

A holiday reflection—I remember…the Christmas that my mother was in the hospital, my father worked three to eleven and we had canned endive fixed in oil for our Christmas dinner—I prepared it—we were all young, I about 14 years old. As we sat down to eat it, the doorbell rang, and it was my mother—brought home by the doctor to spend Christmas night with us. What a joy—how glad we were! And then she went back to the hospital to be operated on the next day.

But there has to be a stopping place in any chronicle, so it may as well be here.

A note from Cecilia Severino, written September 12, 1962: "Today I had a surprise of my life. I needed a paintbrush to refinish the living room drum table, so I went to the basement where my dear husband had some brushes under lock and key. Since his passing away, I had never opened this chest. I found a little bottle in there with some cash of $20 and a note for whoever's birthday came first after his passing away. It is now two years and eight months since he's gone. He still lives on and I love him more."

INDUSTRIALIZATION AND THE STEEL VALLEY

YOUNGSTOWN'S FORTUNES ROSE AND FELL WITH THE STEEL INDUSTRY

James M. Allgren

During the Civil War, heavy industry had grown in the North out of the need to supply the Union with weapons. This growth continued in the postwar period, as westward expansion required numerous support industries. Particular among these were those related to the railroads. Iron and steel were needed for rails, spikes and rolling stock, as well as for construction as frontier towns grew into modern cities.

Nowhere was this expansion as evident as it was in the Mahoning Valley. The increase in the demand for raw pig iron led to a rise in the number of blast furnaces in Youngstown. The Heaton brothers had built the first of these near Yellow Creek [present-day Struthers] in 1803. Between 1849 and 1870, no less than a dozen iron works and attendant rolling mills had been constructed, but these small, independent operations were merely the seeds for the Mahoning Valley's subsequent growth into one of the major steel production regions in the world.

Between 1890 and 1920, seven major integrated steel plants were constructed in and around the city of Youngstown. The mills stretched along thirty miles of the Mahoning River, surrounding the city with their noise, heat and fumes. The Youngstown Sheet & Tube Company sat to the south at Campbell and Struthers, and to the north at Brier Hill.

The giant Ohio Works of the United States Steel Corporation lay west of the city, and the Republic Steel Corporation loomed over downtown.

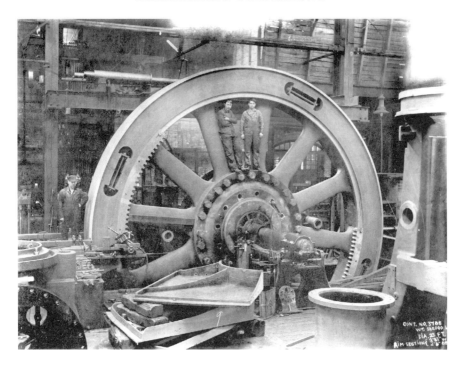

Laborers at a plant in turn-of-the-century Youngstown. *Courtesy of Historic Images.*

Blast furnaces, open hearths and rolling mills dominated the skyline like the castles and cathedrals of medieval Europe. Homes crowded on the hills surrounding the mills, while churches and schools sat in the shadows of these massive monuments of iron, sweat and fire.

The technologies that fueled steel's dominance required great amounts of unskilled labor, a need that was filled by immigrants from southern and eastern Europe and the American South.

"The arrival of these immigrants drastically changed the political and cultural atmosphere of the city, as evidenced by the rise of the Ku Klux Klan in the 1920s," noted Dr. William Jenkins, a history professor at Youngstown State University.

Plant supervisors initially tried to exploit ethnic tensions in order to discourage union organization. These early efforts were partially deterred by the physical environment of the mill. The large, cavernous buildings—filled with huge machinery, deafening noise and searing heat—acted as a great equalizer. Fraught with danger from overhead cranes, ladles carrying hundreds of tons of hot metal, high "catwalks" and noxious gases, the atmosphere made the workers reliant on each other to avoid potentially fatal catastrophe. It was

This image from the John D. Megown Collection depicts the interior of the William Tod Company in downtown Youngstown. *Courtesy of Historic Images.*

in this dangerous environment where the workers sought their livelihood, and in which old ethnic and racial boundaries were overcome by the new culture of the mill.

The sociological impact of the steel plant reached further into the community. The cycles of production and the blowing of the work whistle determined the daily patterns of life. The turn that an employee worked had a direct impact on his life at home and that of his family. For instance, a day-turn worker could expect to follow the normal patterns of his home life in rough coordination with his wife and children. Midnight turn, however, required a radical shift of family routine in order to accommodate the worker who needed sleep during the day. Smoke and graphite dust determined on which days laundry could be hung outside, as well as daily sweeping of walks and frequent window washing.

The factories determined entertainment and recreation. Workers and their families participated in company-sponsored bowling tournaments, and company picnics were held at Idora Park. The Youngstown Symphony was at one time composed of amateur musicians who were steelworkers.

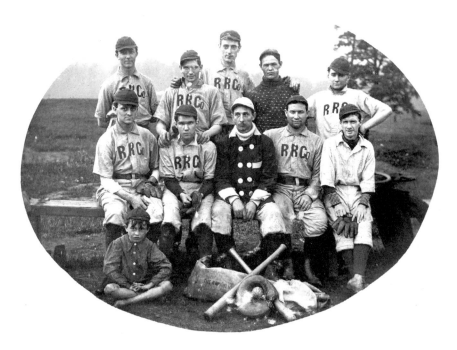

The Republic Rubber baseball team poses for a photograph on September 27, 1906. *Courtesy of Historic Images.*

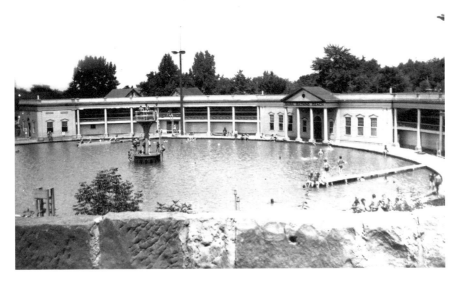

Idora Park's circular pool and bathhouse in 1938. *Courtesy of Historic Images.*

The mills gave rise to a mythology and cultural tradition that were unique to a steel town.

The black smoke that hung over the city was called "pay dirt" because its presence indicated prosperity. Stories of horrible accidents, wildcat strikes and broken production records were passed through generations as sons followed their fathers and grandfathers through the plant gates.

Oral tradition held that if a worker were killed after falling into a ladle of molten steel, the "heat" would be cast and a portion given to his widow to be buried. Great respect was afforded that peculiar creature, the mill rat, said to be the size of a small dog and able to steal an unguarded lunch pail.

The collapse of the local steel industry came on September 19, 1977, a day forever remembered as "Black Monday." The Lykes Corporation announced the closing of Youngstown Sheet & Tube's Campbell Works, eliminating five thousand jobs in what was then the largest plant closing in American history. As the steel industry downsized in the face of depressed markets, foreign competition and new steelmaking technologies, Youngstown was abandoned in favor of lakeshore plants that were closer to raw materials and transport facilities.

By 1985, no basic steel producers remained in the city that once produced one-fourth of the nation's steel. The exodus expressed itself in human terms as well, as families left their roots in the Mahoning Valley in search of prosperity in the South and Southeast.

The imposing presence of the mills literally forged a community and created a unique sense of identity that persists even today. The mills were the physical manifestation of Youngstown's soul, its pride and peril. Their visages were terrifying yet wondrous. Their power was immense, not immortal. Their dangers were the stuff of childhood nightmares and beer-garden legends. Their trains and hammers were instruments that serenaded us. They spoke of backbreaking toil and fierce pride, of thick black smoke softened at dusk by the golden glow that blotted out the stars.

Remembering Renner: Youngstown's Most Famous Brewery

Tom Welsh

The seventy-fifth anniversary of Prohibition passed quietly in 1994—with nearly as little fanfare as the moment Youngstown's city breweries closed their doors in compliance with the Eighteenth Amendment.

The Renner Company operated the most famous of these local breweries, but the city had five at one time or another. Cleveland boasted more than a dozen.

In fact, before passage of the ill-fated Volstead Act in 1919, there were roughly 1,500 breweries across the United States. Upon Prohibition's repeal in 1933, Youngstown's Renner Company was one of 750 that reopened for business.

Five decades later, fewer than fifty American breweries were functioning. By the early 1980s, the site of the Renner Brewery had sat vacant for nearly twenty years.

Pike Street, which once connected Oak Hill Avenue and Market Street on Youngstown's South Side, is closed. Covered with debris, it bears scant resemblance to nineteenth-century photographs of the cobblestone thoroughfare where draft horses hauled wagons of beer. The homes that ran the length of the roadway were torn down during the urban renewal era, and only the ruins of the Renner Company's old keg house suggest the site of a thriving business.

In such a setting, it's difficult to envision this account of the plant's post-Prohibition reopening, published in the *Youngtown Telegram* on June 28, 1933:

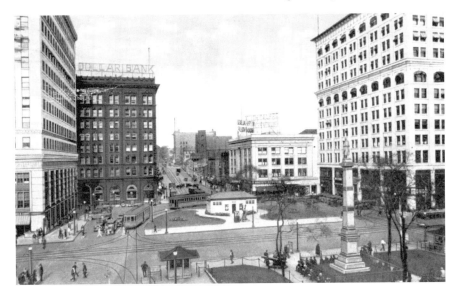

This postcard image from around 1930 depicts the northern side of Central Square in downtown Youngstown. *Courtesy of Mark C. Peyko.*

Twenty-four bottles teetered down a conveyor at the Renner Brewing Company, banged into a steel crate and Youngstown's first legal beer in 13 years was ready for a thirsty public…Full production will be reached at the plant late today when 70 workmen in two shifts of eight hours each turn out 4,000 cases and 300 barrels every 16 hours.

Nearly three more decades would pass before the Renner Company, crippled by national competition and demands for expensive new technology, closed its doors permanently.

Gilbert "Gib" James Jr., of James and Sons Insurance, described the decline of the brewing company founded by his maternal grandfather as "part of a larger trend." The post–World War II domination of national conglomerates that squeezed out the Renner Company would eventually undercut the area's locally owned retail stores and steel manufacturing plants, as well.

James, a one-time trustee at the Mahoning Valley Historical Society, has assembled artifacts to create historically authentic interiors. His most visible project was the Western Reserve Village at the Canfield Fairgrounds. James's collection of memorabilia from Renner Brewery, however, combines his love of family and history.

Among the mementos he has collected are bottles, trademarks, documents, photographs and the weathered lid of a nineteenth-century beer keg. More importantly, he carries memories of a way of life that has all but vanished—one that James feels should be remembered.

The story of Youngstown's Renner Brewery actually begins in the village of Dannstadt, near Swartzburg in southern Bavaria, where George Jacob Renner Sr. was born in 1835. Immigrating to the United States in 1849—supposedly to avoid service in the Kaiser's army—he settled in Cincinnati with his parents. In 1853, after attending brewing school in nearby Covington, Kentucky, Renner married another German immigrant, Sarah Oppelheim. The second of the couple's twelve children, George J. Renner Jr., was born in 1856.

It was George J. Renner Jr. who purchased Youngstown's City Brewery in 1885, reportedly following a tramp's advice that the building was up for sale. Located on Pike Street, the brewery had been established by Matthew Sieger in 1861.

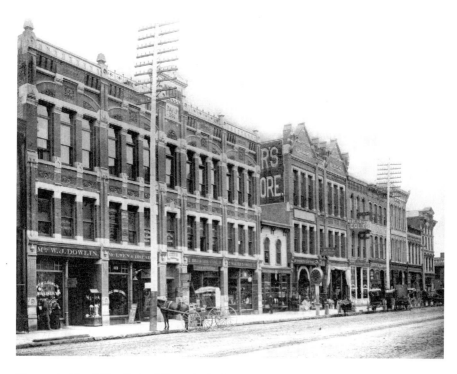

The south side of West Federal Street in the late 1880s. *Courtesy of Mark C. Peyko.*

Efforts to expand and update the Pike Street brewery were temporarily set back by an 1890 explosion and fire that killed the plant's engineer and traumatized Renner's seven-year-old son, Emil. A 1982 article in *Western Reserve* magazine by Gene DeCapua detailed the late Emil "Spitz" Renner's account of the incident. Renner recalled that he and his mother had just returned from a performance of *Uncle Tom's Cabin* at Youngstown's old Opera House when she asked him to fetch a pitcher of beer from the nearby brewery.

"To get through the cellar, you had to go through the boiler house. There was a terrific explosion, and it blew Mr. Richeter's head off, right at his shoulders. It knocked me against the ice machine and the lights went out, but I managed to get out." Renner added that the force of the explosion blew the boiler's hood across the Mahoning River.

Faced with over $80,000 in damage, George J. Renner Jr. was granted a $35,000 loan—without security—from the president of First National Bank. An additional loan, from a Pittsburgh-based malt salesman, provided the brew master with the resources to upgrade the plant and improve distribution. At this time, Renner introduced amber bottles as a supplement to traditional wooden beer kegs.

Around this time, George J. Renner Sr. was also independently operating a brewery in northeastern Ohio. Two years before the explosion in his son's plant, Renner Sr. had purchased and upgraded a primitive plant in Akron.

James recalled his great-grandfather as a tough-minded immigrant who spoke broken English but "ran the show." According to James, the elder Renner bequeathed four hospitals and two churches to the Akron community at his death.

His son was also civic-minded. For instance, in the late 1880s, the Youngstown brewer financed the building of St. Joseph's Roman Catholic Church, which stood on the corner of Rayen and Wick Avenues on Youngstown's North Side.

James suggested that George J. Renner Jr. was a traditional German patriarch—a serious man, who read avidly, consumed a large afternoon meal of sour meats and dumplings, worked long hours at this brewery and relaxed by playing golf at Mahoning Country Club.

But if Renner focused on simple pleasures, successful entrepreneurs of the era—before the advent of the income tax—were expected to live in style. The younger Renner was no exception. On December 16, 1905, the *Youngstown Vindicator* announced the brewer's plans to build on the North Side "one of the finest residences in this city." Projected to cost $40,000, the Georgian Revival mansion was designed to include fourteen main rooms

and numerous bathrooms and pantries. It stands on Park Avenue near Stambaugh Auditorium.

Ursuline Sister Rosemary Diebel recalled visiting her Uncle "Spitz," aunt and cousins at the mansion. She described the magnificent marble staircase, which stretched from the main vestibule to the second floor, and a banquet room featuring golden fixtures and furniture. James remembers well-attended parties where, true to the times, men socialized in one room and women in another.

The same year that George Renner finalized plans for the family's new residence, his son, Emil "Spitz" Renner—a former baseball and football star at the Rayen School—joined the company as a salesman. In 1913, as the business expanded, George Renner officially changed the name of the plant from the City Brewery to the Renner Brewing Company. Five years later, the name was shortened to the Renner Company.

Following the Volstead Act of 1919, the Renner Company made a brief and unsuccessful attempt to market a half-percent malt beverage called "R-E-N-O." Unfortunately, the process used to boil the alcohol out of the "near beer" left it with a burnt taste, and the brewery quickly suspended operations.

"Spitz" Renner was firmly at the helm of the brewing company when the Twenty-first Amendment repealing Prohibition passed in the spring of 1933. Anticipating a $200,000 expenditure to upgrade the plant, Renner hired a then-fledgling contracting company headed by Edward J. DeBartolo Sr. for the remodeling project.

In that same year, Renner introduced technology for canning his product—making transportation easier. Given the option of a flat-topped and cone-shaped can, smaller brewers like the Renner Company selected the latter, because it enabled them to use their old bottling equipment with only slight adjustments. The advent of the tractor-trailer also helped the Renner Company to triple its distribution.

These same advances, however, ultimately made it easier for national breweries to compete with local breweries in their home markets. Still, in 1953, Robert Renner—who assumed presidency of the company in 1949—could announce at that year's annual board meeting that Renner beer had outsold all other beers in the Youngstown area for the first time in the company's history. However, by then the Renner Company was often losing as much as $50,000 a year, James noted, and the family brewery in Akron ceased production in 1957.

Furthermore, technological advances in the industry enabled national breweries to eliminate the bitter edge in their product—resulting in what was

termed "tasteless" beer. Hearty Renner brands—such as "Old German," "Yellow Brand," "Golden Amber" and "Grossvater"—were beginning to seem old-fashioned.

As late as 1961, the Renner Company—amid much publicity—introduced flat-topped cans. However, in the late spring of 1962, demolition for Youngstown's new arterial highway system seriously damaged the Pike Street brewery's cavernous garages. [The company filed suit against the Ohio Department of Transportation on June 30, 1962, and eventually accepted an out-of-court settlement of $82,000.]

Some interpret the setback as the "last straw" in what was becoming an uphill battle for survival. In any event, in November of 1962, the Renner Company ceased operations. The *Youngstown Vindicator* reported that the plant closed "because of the depressed financial state of the immediate distribution territory and because of the insurmountable competition of the large national breweries that have come here with their products at local prices."

That same year, the Renner Company signed a contractual agreement with the Fort Wayne–based Old Crown Brewing Company, permitting them to market their products under Renner trade names until 1976.

In 1963, the Pike Street brewery was purchased by the Andrews Avenue Realty Company, which announced plans to remodel the structure for use as a light industrial warehouse. When the plan was abandoned, a portion of the brewery was razed. Fifteen years later, the remainder of the vacant plant was virtually destroyed by a fire of unknown origin. Today it's difficult to mesh old postcard images of the turreted, German-style brewery with the ruin that sits inauspiciously below the former Southside Medical Center.

Ironically, years after Renner Brewery closed its doors, an increasing number of Americans are turning to darker, full bodied beers—either imports or those produced by microbreweries; and some of the very elements that fell out of fashion with 1960s consumers, such as the Renner Company's elegant labels and bottling, are considered upscale and desirable.

OAK PARK: YOUNGSTOWN'S PROGRESSIVE HOUSING EXPERIMENT

Mark C. Peyko

Oak Park looked like a little Spanish colonial settlement—more fitting in the American southwest than on the North Side of Youngstown.

An Oak Park house on Youngstown's lower North Side in 1992. *Courtesy of Mark C. Peyko.*

However, that wasn't what the Modern Homes Company was trying to recreate when it organized in 1909 to build inexpensive "modern, sanitary and semi-fire proof" rental housing for Youngstown's working class.

The company built rows of unattached houses and one terrace apartment, using hollow concrete tile finished with a stucco-like facing. Oak Park originally was sited on a diagonal from Andrews Avenue and continued southwest toward Walnut Street. The development enclosed a large, open green space, which was landscaped with oak trees, shrubbery and grass.

According to the 1913 publication "Youngstown: City of Progress," each house in Oak Park was designed to include modern conveniences like bathrooms, hot air furnaces and laundries. Depending on family needs, units ranged from three to seven rooms. Rent was ten to twenty-five dollars per month.

In 1909, J.M. Hanson, a charter member and secretary of the newly formed Modern Homes Corporation, cited the need for modern, inexpensive housing in the city: "Two and three families are crowded in houses not fit for one family…and the congested condition is rapidly increasing." H.M. Garlick, president of the Dollar Savings and Trust Company, served as president and treasurer of the quasi-philanthropic housing company.

According to a 1913 Youngstown Chamber of Commerce report, Modern Homes had constructed 110 housing units in the city between 1909 and 1913.

By 1915, the Youngstown City Directory listed sixty-two Oak Park addresses, and all tenants were identified as blue-collar laborers. Louis Smith (a machinist) lived at 1 Oak Park, and Samuel Dudley (a laborer) and his wife, Amy, occupied 3 Oak Park. Crane and motor operators, conductors and the like occupied other units. Youngstown city directories list the company's years of existence as spanning from 1910 through 1918.

Construction of the Madison Avenue Expressway in the mid-1960s sheared off many of the houses in the Oak Park development, leaving the settlement without much of its southwestern enclosure. Today the original plantings in the commons area are mature, making the remnants of Oak Park seem like a small residential campus.

DESPITE APPARENT BENEFITS, WPA PROGRAM WAS FRAUGHT WITH CONTROVERSY

Mark C. Peyko

Much has been said about the Works Progress Administration of the 1930s, but nostalgia has clouded the memory. Although the WPA kept many Mahoning Valley families solvent during difficult times, the Depression-era program was fraught with controversy and frequent labor strife throughout its existence.

Today what Youngstown men and women built outlasts the contentious labor conflicts, the "shameful" memories of being on public "relief" and the anger and betrayal of veteran laborers forced to work in a government aid program. Firsthand newspaper accounts are helpful in explaining what Youngstowners really thought of the work program at the time.

President Franklin D. Roosevelt created the Works Progress Administration following a decree. Youngstown, like every participating municipality in the nation, had to provide a portion of the funding for projects prior to receiving federal aid.

In the August 9, 1935 edition of the *Youngstown Telegram*, Youngstown city finance director Hugh D. Hindman noted that the start of the WPA program meant that the city and county had to immediately provide funds to buy materials for proposed projects. Assistant County Engineer Luther T. Fawcett said that Mahoning County's share for materials would be taken from the state's gasoline tax fund.

The WPA work program began in Mahoning County on August 16, 1935, when 955 local men joined the relief workforce. By November 1, 4,000 people were employed in the program.

When a women's program was initiated in late fall, the total workforce increased to 7,400. By February 1936, the average workforce neared 8,000 persons, the limit.

In February 1936, the *Youngstown Vindicator* reported that the federal government had spent $2 million of the $3,239,000 allocated to Mahoning County and took thirty-two thousand people off the county relief rolls. [The figure was based on the assumption that WPA workers were the heads of households and that an average family consisted of four people.] However, news accounts simply listed workers as "men." Although females were part of the vast WPA network, they were employed in traditional domestic capacities in addition to bookbinding and clerical work.

WPA employees worked a maximum of 130 to 140 hours per month, or 32.5 to 35 hours per week. In counties with cities exceeding 100,000 people,

WPA paid fifty-five dollars per month for unskilled labor, sixty-five dollars for intermediate labor and eighty-five dollars for skilled labor. Professional and technical workers earned ninety-four dollars per month. If today's worker finds this wage scale surprisingly low, it's interesting to note that WPA employees and Youngstown's local labor unions took issue with the pay scale in the 1930s. This pay scale ultimately would incur the wrath of employees and was challenged by local unions.

The scope of WPA projects was far-reaching and exceeded the familiar park picnic pavilions and stone retaining walls found in Youngstown schoolyards. Although popular local history tends to remember the athletic stadiums, swimming pools and town halls, humble projects far exceeded the high-profile ones.

Local newspaper accounts provide a detailed understanding of the WPA in the Mahoning Valley. In the microfilm department at Youngstown's Main Library, researchers will find accounts of every local project. Newspaper accounts of the period are quite thorough: articles cite the task, funding ratios and number of workers assigned to individual projects.

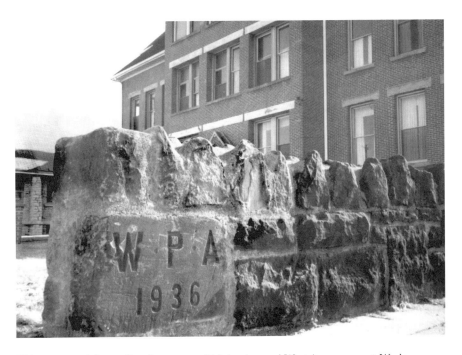

This stone retaining wall at the corner of Mahoning and West Avenues was a Works Progress Administration project from 1936. *Courtesy of Mark C. Peyko.*

Newspaper articles also listed the mundane—from the paving of Pyatt Street with four inches of brick to the cleaning and painting of bridges No. 31, No. 30. and No. 28 in Poland Township. As evidenced by newspaper articles from the 1930s, many local WPA projects were capital improvements that greatly helped modernize the county's infrastructure. Between 1935 and 1936, WPA projects improved 90 miles of roads in Youngstown and Mahoning County. Over 42.5 miles were new rural or farm-to-market roads requiring grading, drainage and a base of stone quarried and crushed by WPA laborers.

The work in rural Mahoning County appeared to significantly improve the quality of life in many communities. One grateful rural resident, quoted in a 1936 *Vindicator* article, said that doctors were now accessible and that her children could go to school without being carried miles in the mud, snow and ice to a school bus. These rural roadways cost about $16,000 per mile to build.

Mahoning County received the largest funding allotment for roads in the state. The WPA appropriated $2,524,648 for 206 miles in Mahoning County. In nearby Trumbull County, 168 miles were constructed for $705,206 and Columbiana County had 67 miles of roads built for $302,292. The total spent in the state was $37.6 million, of which local communities contributed $4.6 million.

A controversial agency, the WPA often was plagued with problems. Sometimes local labor unions challenged WPA wage scales and practices. Other times, discontent was internal. Many WPA workers quoted in Youngstown's two daily newspapers complained of low wages and noted bitterly that they had been displaced from long-term employment in local industry.

In *The Green Cathedral*, author John C. Melnick recalled how WPA workers were sometimes subject to ridicule. Melnick described—in what now sounds like urban legend—the story of a WPA worker who was assigned to direct traffic near Mill Creek Park, where an extensive government project was underway. Due to laryngitis, the traffic coordinator's voice was barely audible. When the worker flagged down a motorist to tell him in a barely audible whisper that the WPA workers were just ahead, the motorist replied, "I won't wake them."

As the WPA workload increased in the Mahoning Valley, many local trades complained that WPA wage scales undercut union base wages. In Lowellville, the construction of a new city hall provided fuel for a contentious labor conflict. In 1935, when the WPA summoned ten tradesmen—four bricklayers, two plumbers, two electricians and two carpenters—to the site, many local unions challenged the action.

Tales from the Mahoning Valley

Andy Hubbard, business agent of the Carpenters' Union, and Crawford Drummond, business agent of the Bricklayers' Union, objected to the hiring of nonunion workers. In a 1935 article in the *Vindicator*, Hubbard admonished the ten prospective workers, stating, "Our union has fought for a good many years to raise the wage standard; There is only one way a union can look at you men if you go to work." Hubbard vowed that the WPA conflict in Youngstown would be the first matter considered by the Ohio Federation of Labor when it convened the following week in Columbus.

Workers offered a mix of opinions, too. Many were grateful for the work, especially those with dependents and home mortgages. Others, when quoted anonymously, complained of low wages and difficult projects. Many said that they were angry after being displaced from well-paying jobs in local industry.

In a newspaper account from 1935, one worker said anonymously that he was "grateful for the opportunity to work for his relief" but complained about the wage scale. "When you make a man work for less than 50 cents per hour, he's not going to give you his best work. Wages should at least be 50 cents an hour."

Some newspapers of the period found WPA workers saying that they were ashamed to be in jobs they considered "relief." Many vowed to seek "legitimate" work as soon as the economy got better. A reporter surveying a cross section of relief workers in 1938 found that many laborers—some who had been working steadily for as long as twenty years—were "ashamed to be accepting WPA wages or relief orders." Because of the stigma associated with government relief work, many refused to identify themselves. Others simply gave their initials.

One man, simply listed as "E.T.," was a former employee of the Republic Steel Corporation from 1924 to 1937 and, when quoted in the summer of 1938, was on public relief. E.T., disabled by a stroke, called his family's situation "a bitter pill to take" and noted that he was "used to working for his food." Another man, a furloughed millworker simply identified as "P.D.," said he and his family were "ashamed to have their neighbors know they are on WPA."

However, others, like John Light of 919 Tod Avenue, were grateful for the work. "I'd rather work anytime for what I get rather than have it handed to me without doing anything for it," he said. Light, along with a crew of seventeen workers, was improving Pyatt Street on Youngstown's South Side. Others voiced gratitude, if only halfheartedly. A *Vindicator* reporter interviewing WPA workers found many sardonically noting that it was "better than starving."

By 1938, the *Youngstown Vindicator* reported that sixty thousand people, or one-third of the county's population, were either receiving relief or employed by WPA. "The proportion of the population receiving public aid has grown during the recent Depression to the point where the jobless are no longer ashamed on being on WPA, or relief," noted County Relief Director Isadore L. Feuer. Many had "outgrown the pre-Depression psychology of 'charity,'" he added.

"This [the Depression] has brought home to the vast majority of the population the conception of permanent public assistance. When three or four neighbors on your block are on WPA, even though they live in good modern homes, you begin to comprehend the widespread affect of the Depression," Feuer concluded.

WPA PROJECTS: A SAMPLING

The following list does not include all WPA projects but rather highlights significant or interesting projects in Youngstown and Mahoning County.

Schools

By 1938, extensive work had been completed in Youngstown schools. Workers repainted and redecorated buildings, landscaped, repaired and replaced electrical wiring and fixtures, upgraded plumbing, varnished desks and woodwork, improved playgrounds and athletic fields, built retaining walls and repaired worn books. Many Youngstown city schools were rewired or had new electrical fixtures installed. A 1930s addition to Poland Seminary High School cost $200,000. The federal government allotted $100,263 in WPA funds for labor. A new high school stadium was started in May 1937 in Struthers, Ohio, with $42,000 in WPA funds. The stadium seated 3,500 and was equipped with floodlights, showers and dressing rooms. Workers graded and leveled the athletic field, completed one thousand cubic yards of excavation and laid 1,800 feet of drain tile.

Parks and Recreation Projects

Five stone picnic shelters were built in Youngstown using stone quarried at Haselton. The shelters, maintained by the Youngstown Parks Department, were sited at the Municipal Golf Course and Crandall, Pine Hollow, Bailey and South Side Parks. The WPA constructed 1,500 feet of trails in Mill

Creek Park by clearing and grading. WPA constructed dry stone walls to hold embankments when necessary. In May 1938, a $109,423 grant created Roosevelt Park, a sixty-five-acre recreation facility on Struthers-Liberty Road in Campbell. WPA funding aided the construction of tennis courts, pools, playgrounds and a football field. In other projects, workers graded, leveled, enlarged and installed equipment at fifteen Youngstown playgrounds.

Public Buildings

In Milton Township, workers rebuilt the town hall. In Sebring, workers revamped the Sebring municipal plant. In Canfield, workers constructed a 3,800-seat grandstand at the county fairgrounds. In addition, WPA workers built a fire station in Austintown Township with stone from the Haselton Quarry.

Streets and Sewers

In Youngstown, workers constructed 17.5 miles of roadways and widened roads, installed curbs and built drainage ditches at Bear's Den Road, Midlothian Boulevard, Shady Run Road and Southern Boulevard. WPA workers resurfaced 7.5 miles of roadway in the city. In Youngstown and Campbell, workers built 2.7 miles of storm sewers and 0.7 miles of sanitary sewers, and 1.1 miles of water mains had been constructed from the western limits of Youngstown to the western limits of Austintown.

"LITTLE STEEL STRIKE" BECAME DEFINING MOMENT IN YOUNGSTOWN LABOR HISTORY

Marie Shellock

Gunfire rang out. Strikers and sympathizers fell to the ground. Two people died at an entrance of the Republic Steel Mill on Poland Avenue in Youngstown, and many were wounded.

It was the third week in June of 1937, and steelworkers had been on strike against the "Little Steel" companies for about a month in a collection of mills around the southern and western shores of the Great Lakes. Other cities also saw shocking violence, including Chicago, where ten people were slain as police fired on a Republic Steel picket line.

These developments in the history of relations between American labor and management took place in the late 1930s on ground that was laden with iron ore that, poured into iron and cast into steel, shaped the United States into a robust industrial nation.

Around the world, conditions were developing that, in just a few years, would lead to the Second World War—a conflict that would rely on the iron ore that would come from the Great Lakes region.

By all accounts, Big Steel consisted of the United States Steel Corporation and, by some accounts, Jones & Laughlin Steel Corporation. The Little Steel manufacturers were so-named because they were smaller in output than Big Steel but were still major, independent steel companies. Locally, Little Steel included Republic Steel and Youngstown Sheet & Tube.

After Big Steel signed a labor agreement with the Steel Workers Organizing Committee (the predecessor of the United States Steelworkers) in March 1937, SWOC set its sights on Little Steel. The smaller companies were adamant in their refusal to sign contracts with SWOC and decided to endure strikes instead—even if the work stoppages proved deadly. Here, two

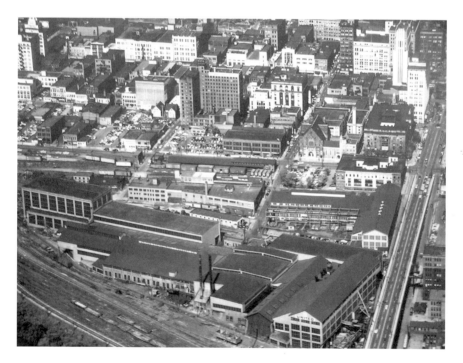

An overhead view of downtown Youngstown and the Mahoning River, circa 1950. *Courtesy of Historic Images.*

Youngstown Sheet
and Tube in 1942.
*Courtesy of Historic
Images.*

died and forty-two were injured in violence on June 21, 1937, at the main entrance to Republic Steel's Poland Avenue plant in Youngstown.

Turmoil in the 1930s—The story of the Little Steel Strike of 1937 is a story of management and labor that embroiled the Mahoning Valley in tension and violence, but the events eventually improved the lives of workers and their families, firmly carving out a role for unions in American life. The American steelworker became one of the best-paid laborers in the world, as steel remained king throughout most of the twentieth century.

"The most significant, direct result of the strike was the transformation of the labor movement in not only the steel industry, but all heavy industries, from basically local and ineffective organizations into all-encompassing, nationwide collective bargaining representatives of American workers," wrote William Lawson, historian and executive director of the Mahoning

Valley Historical Society, in an academic analysis written in 1987. Besides wages and benefits, labor contracts gave American steelworkers previously unheard-of safety standards in the workplace.

In Youngstown, the Little Steel Strike was for many years memorialized on Public Square with a historical marker until the renovations of Federal Street uprooted it. The marker was recently relocated and rededicated on the grounds of the Youngstown Historical Center of Industry and Labor at 151 West Wood Street. The marker recalls a time when workers took their grievances to the pavement and shed blood to fight for a fair deal.

Indeed, Congressional hearings in 1938 revealed that the Little Steel companies had stockpiles of weapons that they were prepared to use against strikers. Youngstown Sheet & Tube Company officials testified that its arsenal contained $10,000 worth of tear gas, 8 machine guns, 452 revolvers, 314 pistols and 190 shotguns, the *Vindicator* reported in an Associated Press story. Backed with such firepower and the will to use it, Little Steel management stood its ground.

Background—The movement toward unionization of the steel industry was begat in blood in the late 1800s, when the Amalgamated Association of Iron, Steel and Tin Workers was locked out of the Carnegie Company Plant at Homestead, Pennsylvania. The immediate issue was the intention of Andrew Carnegie to cut employee wages. On July 6, 1892, a riot over the scheduled reopening of the plant with nonunion labor left ten people dead and dozens injured.

On January 7, 1916, in East Youngstown, current-day Campbell, guards at Youngstown Sheet & Tube's mill opened fire on a crowd of striking steelworkers, killing 3 and injuring 125. The crowd rioted and burned six blocks of the business district. The next day, 2,000 National Guard troops arrived to restore order.

Later, steel strikes were fought in the halls of law more than on the streets. For example, in 1952, in the case of *Youngstown Sheet & Tube v. Sawyer*, President Harry S. Truman ordered seizure of the nation's steel mills. His purpose was to fend off a strike that he claimed would harm the United States during the Korean War. The steel companies sued the president on behalf of Congress, saying that the presidential action had violated the constitutional doctrine of the separation of powers. Six high court justices agreed.

In 1959, in a case that many believe led to the first significant import of foreign steel, the United Steel Workers struck over management's ability to modify work rules. In a 116-day strike, the USW kept the contract language and achieved minimal wage increases. Many believe that this strike initiated the devastation of the American steel industry.

PART III

SPORTS, RECREATION AND POP CULTURE

YOUNGSTOWNER'S ICE CREAM INVENTION STICKS WITH US

Mark C. Peyko

The ice cream bar was such a logical invention that it seems the Romans or ancient Egyptians should have given it to the world. Yet it wasn't until the early 1920s that Youngstown confectioner Harry Burt Sr. and his children came up with a treat whose popularity is now international.

The story is now local legend. In January 1920, Harry Burt Sr. and his two children, twenty-three-year-old Ruth and twenty-one-year-old Harry Jr., were at the family's downtown ice cream and confectionery business trying to come up with a new ice cream treat to offer customers.

After tasting a rectangular piece of vanilla ice cream that had been dipped in chocolate, Ruth Burt remarked that the treat was "delicious, but too messy to handle." Her younger brother, Harry, then offered a suggestion: "Let's put handles on them the way they do candy suckers."

"Son, I think we have something," Harry Sr. interjected. After two hours of experimentation, the ice cream bar was created in Youngstown, Ohio.

As local historical accounts have noted, Harry Burt Sr. took bells from an old bobsled and attached them to a refrigerated vehicle, thus creating the world's first ice cream truck. He then dispatched a fleet of twelve white "Good Humor" vehicles to canvass Youngstown's city streets.

Harry Burt's "Good Humor" men were outfitted in crisp, white uniforms to project a sanitary and wholesome image. The ice cream company's name, Good Humor, resulted from Burt's belief that what you ate could affect your

A 1931 magazine ad promoting Burt's Arbor Garden in downtown Youngstown. *Courtesy of Historic Images.*

A promotional ad for the Youngstown-based Good Humor Company advertises owner Harry Burt's recent invention—the ice cream bar. *Courtesy of the Mahoning Valley Historical Society.*

disposition. In short, Burt maintained that his company's ice cream would put customers in a "good humor."

Harry Burt knew that his invention and innovations had value, and he was wise enough to seek protection from the United States Patent and Trademark Office. However, after repeated attempts to obtain a patent were denied, the confectioner traveled to Washington, D.C., with a five-gallon tin filled with ice cream bars. He returned to Youngstown with his patent.

Harry Burt Sr. died in 1926, and the rights to the Good Humor Company were sold to Cleveland investors shortly thereafter. The downtown ice cream parlor, which was located at 325 West Federal Street, operated until 1929.

Although Harry Burt Sr. did not live to see the lasting impact of his invention, the ice cream bar and the way Burt marketed it have become an enduring part of American popular culture. Even Hollywood saw the appeal of this sunny moment in Youngstown history. In the early 1950s, Columbia Pictures produced a movie about the Good Humor Company that starred Jack Carson.

Today the jingling bells that announce an ice cream truck's arrival on beaches, boardwalks and city streets are commonplace. Moreover, a variety of frozen treats, from neon Popsicles to upscale Häagen-Dazs bars, owe a debt to Burt's resourcefulness—as do the parents who give in to their children's pleas for ice cream each summer.

YOUNGSTOWN, THE CITY THAT PRODUCED THE WARNER BROTHERS

Tom Welsh

It was every film buff's waking dream.

As he sat in the executive dining room at the Warner Bros. Studios, eighteen-year-old Joe Shagrin Jr. noticed a familiar face at the next table, one he instantly recognized from crime classics like *The Public Enemy* and *White Heat*.

Movie mogul Harry Warner, who was seated across from Shagrin, followed the young man's gaze and shrugged. He then told the story of how film tough guy James Cagney became the only actor allowed to dine with the studio's executives when he made the privilege a term of his contract.

The formal introduction to Cagney that came next remains one of Shagrin's most vivid memories of the single trip he paid to Hollywood with his late father, local theatre owner Joe Shagrin Sr. The senior Shagrin, who

Youngstown magazine *Town Talk* heralds the opening of the Warner Theatre on its cover in 1931. *Courtesy of Historic Images.*

The cover of the program for the Warner Theatre's opening night. *Courtesy of Historic Images.*

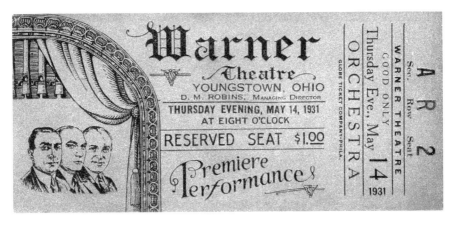

A ticket stub for opening night at the Warner Theatre on May 14, 1931. *Courtesy of Historic Images.*

operated the Foster Theatre in Youngstown from 1938 to 1965, befriended the Warner brothers during their early years in Youngstown.

However, Joe Shagrin Jr.'s most precious memory of that afternoon more than fifty years ago came when Harry Warner, the eldest of the brothers, escorted him and his father to the studio's famous Trophy Room. There, amid rows of Academy Awards, Shagrin's eyes settled on the image of a Rayen High School baseball uniform.

"They had this beautifully framed photograph of the youngest Warner brother, Milton, which had a place of pride in the Trophy Room," he recalled. Shagrin had heard, years before, about the tragic fate of Milton Warner, a former high school baseball star who died of a ruptured appendix in 1915—just weeks after pitching two no-hitters for the Cleveland Indians.

For Shagrin, the placement of the high school photo underscored the Warner brothers' strong connections to, and continuing interest in, the Youngstown area.

Many area residents are familiar with the local origins of the Warner brothers—Harry, Albert, Sam and Jack. They have read descriptions of how Sam Warner, the most popular of the brothers locally, became so intrigued by the possibilities of the Kinetoscope that he took a job as a projectionist at Idora Park in 1903.

It was in a little house on Youngstown's lower North Side that Sam Warner convinced his Polish-Jewish family to pool its resources to buy a used projector and worn reel of *The Great Train Robbery* for $1,000. One year later, the brothers opened their first entertainment house, the Cascade Theatre, in New Castle, Pennsylvania.

By 1917, after opening two more theatres and testing the limits of the film distribution business in Pittsburgh, the Warner brothers decided to make the leap to production and started filming features at the old Vitagraph Studios in New York.

One year later, they moved to Hollywood to establish what many film historians consider the most influential studio in the history of U.S. cinema.

What is less well known to locals is that the Warner brothers maintained an intricate network of relationships in the community decades after their studio hit "pay dirt" with the release of the industry's first full-length "talkie," *The Jazz Singer*, in 1928.

Area natives who took positions at the Warner Bros. Studios included Joseph Marx, who served for a time as casting director, and William Schaefer, executive secretary to Jack Warner, the youngest and most colorful of the mogul brothers.

Joe Shagrin Jr. recalls that his uncle, Max Shagrin, operated a string of theatres for the Warner brothers in San Francisco in the 1920s. Later, he worked closely with Warner Bros. and other studios as a representative of character actors, many of whom he recruited from northeastern Ohio.

Among the more prominent character actors Max Shagrin recruited from this area were Joan Dithers, the foil of Shirley Temple who was known to a later generation as TV's "Comet Lady," and George Tobias, a veteran of Warner Bros. adventure films who later played the long-suffering Abner Kravitz on the TV sitcom *Bewitched*.

He was less successful in securing a Warner Bros. contract for a skinny nineteen-year-old named Tyrone Power, whom he sent back to New York with the advice to get more experience and "put on some weight."

Scores of Youngstowners who made the move to Hollywood congregated at Los Angeles' Farmers Market, where they purchased painted ties from Frank Williams, a transplanted Ohioan who once ran a business on East Federal Street.

In 1931, the Warner brothers opened a business of their own in downtown Youngstown. In May of that year, a local magazine, *Town Talk*, dedicated an entire issue to the opening of the world-class Warner Theatre. It was initially managed by Warner in-law David Robbins.

One article highlighted the opulence of the building, with its glowing description of the theatre's Grand Lobby: "On each wall are several great, artistically etched, divided mirrors reaching to the beautifully designed ceiling. These mirrors are placed between pilasters of faintly tinted marble."

Tales from the Mahoning Valley

Most readers will recognize the space described in the article as the lobby of what is now the Youngstown Symphony Center. In the late 1960s, the theatre, slated for destruction, was saved by a $250,000 gift from the Powers family.

A cache of letters included in the Mahoning Valley Historical Society's Jack L. Warner Collection reveals intimate signs of the Warner brothers' enduring affection for the community. Much of the correspondence in the collection is addressed to local furniture retailer Myron Penner, whom Jack Warner playfully addresses as "O'Brien"—a possible reference to an old vaudeville routine.

Not surprisingly, Jack Warner, a complex and insecure man, betrays mixed feelings about his hometown—in one letter expressing a wistful desire to see the "old Diamond" of Youngstown again, in the next asking plaintively, "Have they cleaned the buildings yet?"

Ultimately, he would dismiss Youngstown as "a graveyard of memories" in his 1964 autobiography *My First Hundred Years in Hollywood*.

For the most part, this tone is maintained in a 1968 letter to Penner, in which he comments matter-of-factly on the closing of the Warner Theatre in Youngstown: "Am sorry to hear this, but progress can't be stopped," he writes tersely.

However, Warner betrays more than passing interest when he adds, "If there are any other stories around about the opening or closing of this theatre, will appreciate your airmailing them to me here at the studio."

Decades after the death of Jack Warner, the last of the Hollywood moguls, Youngstown's impressive Symphony Center and New Castle, Pennsylvania's restored Cascade Theatre are among the few tangible reminders of the area's former role as a regional entertainment center.

Further efforts to commemorate the Warner brothers' local origins have not always been successful. A 1990s campaign to relocate the studio's Trophy Room to Youngstown, for instance, fizzled when representatives from Time Warner, Inc., refused to cooperate.

In the end, it may be that the most enduring legacy of the Warner brothers' connection to this area will be discovered in the films themselves.

Many Hollywood historians, including Jack Warner biographer Bob Thomas, have drawn parallels between the tough-talking atmosphere of early twentieth-century Youngstown and the gangster slang found in many of the studio's features.

One popular story, perhaps apocryphal, even has Jack Warner snatching up a screenplay of W.R. Burnett's gangster novel *Little Caesar* because its protagonist is a Youngstown thug who climbs to the top of the Chicago mob.

It may be no less appropriate, however, to link the Warners' early experiences in the Youngstown area to what many consider a positive, underlying theme of their most powerful films, from *The Black Legion* [1937] to *Confessions of a Nazi Spy* [1939] to *Casablanca* [1942]: the compelling need to combat intolerance.

The studio's overlooked role in opposing domestic vigilantes and European totalitarianism through film finally received the treatment it deserved in Michael E. Birdwell's book *Celluloid Soldiers: The Warner Bros. Campaign Against Nazism*. The Warner brothers' uncompromising opposition to all forms of religious and ethnic bigotry would have sat well with many of their former neighbors in Youngstown, Shagrin said.

SINATRA PLAYS THE PALACE: WITCHCRAFT—EVEN IN 1942

Mark C. Peyko

In compact disk liner notes that I read a long time ago, a critic once said: "There are two kinds of people—those who dig Sinatra and those who do not."

When Frank Sinatra played a three-day engagement at the Palace Theatre in downtown Youngstown in 1942, apparently most everyone was in the first category.

"It was so noisy, you could hardly hear," recalled Marilyn [Smith] Kane of Youngstown, who attended one of the concerts at the Palace Theatre. "The girls were screaming so much…I don't remember anyone fainting, though."

Kane confirmed that this type of unbridled hysteria was unique in the big-band era. "I remember seeing Cab Calloway and Pearl Bailey—when she was just staring out—and nothing like that ever happened."

Sinatra played Youngstown for three days in 1942—from Tuesday, August 25 through Thursday, August 27—when he was a vocalist in the Tommy Dorsey Orchestra. The bill also included Jo Stafford of the Pied Pipers, Buddy Rich and Ziggy Elman.

The Dorsey Orchestra was winding up a tour of the Midwest, and Youngstown was sandwiched in between engagements in Akron and Indianapolis. While in Youngstown, the Dorsey Orchestra played five shows daily. The final Youngstown show was broadcast on radio nationwide from the Palace Theatre stage.

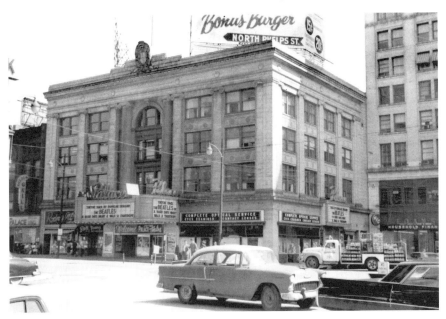

When Frank Sinatra played the Palace in the early 1940s, Youngstown's bobbysoxers screamed and swooned. "A Hard Day's Night" was luring a different generation to the theatre in 1964. *Courtesy of Historic Images.*

The Youngstown engagement was one of the last times that Sinatra performed with Dorsey. By early September, Sinatra left the Dorsey Orchestra to go out on his own.

In *Frank Sinatra: An American Legend*, author and daughter Nancy Sinatra recalled, "Dad's departure from the band was announced on stage during a performance at the Circle Theatre in Indianapolis." [The Indianapolis shows occurred one day after Youngstown.] Johnny Kay, a radio personality at WNIO in Youngstown, attended one of the Youngstown shows and noted that Sinatra announced his plans to go solo while performing in Youngstown.

Always looking for better career opportunities, Sinatra officially ended his tenure with Dorsey on September 8, 1942. However, the stubborn bandleader refused to release Sinatra from his contract like Harry James had done just a few years earlier. As Nancy Sinatra recalled in *An American Legend*, her father thanked Dorsey for all that he had done but said it was time to move on. "I don't think so," replied Dorsey, emphasizing that he was going to hold Sinatra to the terms of the contract: "43 percent of his professional income for life."

After acrimonious negotiations [Sinatra's legal representatives reportedly threatened to have Dorsey banned from broadcasting on NBC radio], the bandleader finally agreed to a buyout for $75,000.

Sinatra was now free to perform as a soloist, but the parting wasn't friendly. Dorsey reportedly told Sinatra, "I hope you fall on your ass."

Dorsey's wish didn't come true for a few years. Sinatra enjoyed a wildly successful run in the early to mid-1940s. However, by 1950 the crooner was all but washed up. Sinatra was dropped from Columbia Records and the MGM Studios, where he had made motion pictures during his first career peak.

But ever the fighter, Sinatra lobbied for the role of Maggio in *From Here to Eternity* in 1952. The role launched one of entertainment's most stunning comebacks.

GEORGE "SHOTGUN" SHUBA AND JACKIE ROBINSON: "A SILENT, SEMINAL MOMENT IN BASEBALL HISTORY"

Christine Davidson

George "Shotgun" Shuba of Austintown sat at his Royal manual typewriter, watching the chickadees that alighted on feeders outside the glass doors of the family room, and reflected on his life. To the right of where he sat hung an enlarged photograph of a moment in his life that forever changed the game of baseball and life in the United States.

The black-and-white photo captures a twenty-one-year-old Shuba extending his hand to twenty-seven-year-old Jackie Robinson just as he's crossing home plate. Robinson, smiling broadly, appears to be floating on air as a smiling Shuba congratulates him. The *New York Times* called the greeting "a silent, seminal moment in baseball history." The *Taipei Times* labeled it "the first black-white home run handshake." The *Beacon Journal* described it as "a simple gesture that bridged baseball's racial barrier."

It was April 18, 1946, as the Montreal Royals of the International League took on the Jersey City Giants. In his second at bat of his minor league debut, the Royals' Robinson smacked a 335-foot home run over the left field fence at Roosevelt Stadium.

Shuba, hitting third and waiting in the on-deck circle, said that his reaction to Robinson's homer had nothing to do with race. He recalled the exact moment: "It didn't matter that Jackie was black, he was the best guy on the team, and he was my teammate. He could have been Technicolor, it didn't matter to me."

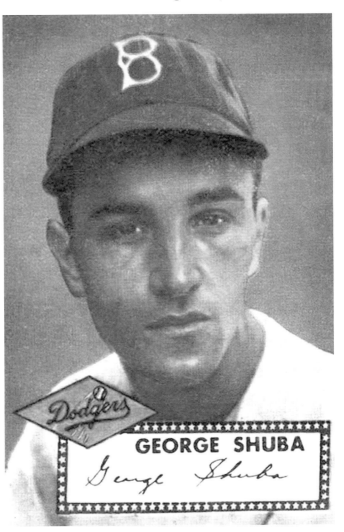

A bubblegum card for George Shuba of the Brooklyn Dodgers.

However, it did matter to sportswriters and the American public. Online sources report that Shuba is most often remembered for "his role in breaking down Major League baseball's tenacious color barrier." Shuba stepped into history as America's conscience before a New Jersey sellout crowd of twenty-five thousand and a gaggle of sports reporters and photographers.

Robinson went on to his spectacular career as the Brooklyn Dodgers first and second baseman, winning the National League's "Rookie of the Year" award in 1947 and the National League's MVP in 1949.

Shuba joined Robinson with the Dodgers in 1948 and by that time had earned the nickname "Shotgun" because, according to sportswriter Bill

Bingham, "he sprayed line drives as if they were buckshot." This nickname is rated as one of the all-time favorites by baseball fans.

Over his career, Shuba batted .259 with 24 homers and 125 RBIs. Shuba was the first National League pinch hitter to pinch-hit a home run in World Series history. He helped the Dodgers win pennants in 1952, 1953 and the World Series in 1955. In addition, a chapter of Roger Kahn's novel *The Boys of Summer* is devoted to Shotgun.

Shuba said that his favorite baseball movie is *It Happens Every Spring* from 1949. It's one of those wacky sports comedies released by 20th Century Fox. Welsh actor Ray Milland plays a chemistry professor who accidentally develops a concoction that repels wood. Shuba slapped his knee and laughed as he further explained the plot. "So, of course, he breaks into the majors because nobody can hit his pitches."

It was anything but an accident that Shuba landed in the majors. A passage in Adam Kahn's self-help book *Stuff That Works* details a ritual that Shuba began as a youngster and continued through his playing career, and it's one of the reasons Shuba became a success. "George 'Shotgun' Shuba tied a rope to the ceiling, and made knots in the rope where the strike zone was, and every day he swung a bat at the rope 600 times. He swung that bat 600 times a day until he was in the Major Leagues. That's how he got his great 'natural' swing," Kahn said.

The youngest of ten children born to Slovak immigrants, Shuba grew up on Youngstown's West Side. He attended Holy Name School, where a classroom encounter with a nun would affect his future life.

I was sitting in the last row and my buddy is sitting next to me and somebody misbehaved so the nun gave everybody homework for the weekend. So, I said to my buddy, "Give me liberty or give me death." The nun said, "Who said that?" Nobody answered and I'm bluffing her. She says, "Well, I'm not going to let the class go home until that person raises his hand."

So, I raised my hand and I said "Patrick Henry." She came down [the row] and hit me, really hit me. I went home but didn't tell my mother how it happened and she put a hot water bag on my ear, but then I went to swim at Borts Pool. I dove into the deep water and wow! It was like somebody put a nail in my ear. That kept me out of the Army, that perforated eardrum. So, it was a blessing in disguise. Otherwise, I might still be in Germany.

Shuba can now only hear with the assistance of an aid, and Mike, his son, said that he and his dad are starting a foundation to help children suffering from hearing loss.

The younger Shuba handles his father's schedule for speaking engagements, interviews and trips. In March of 2007, they spoke to six hundred Canfield students and another group at Ohio Wesleyan. In 2006, during the sixtieth anniversary of the historic handshake, he and his dad raised $7,800 for a charity event sponsored by the Ottawa Lynx Minor League baseball club in Canada.

The younger Shuba called it a promotion for doing the right thing. "It's a celebration of what George and Jackie stood for that day," Mike Shuba said. At the event, two young children—one wearing George "Shotgun" Shuba's uniform number and the other wearing Jackie Robinson's uniform number, restaged the home run and historic handshake.

After a bout with Graves disease, Shuba retired from baseball in 1957 and returned to Youngstown. He's been married to his wife, Kathryn, since 1958. More recently, Shuba has been writing his memoirs with the help of newspaper clippings compiled by his sister, Helen. She has saved everything ever written about her brother in nine big scrapbooks.

PART IV

PROMINENT CITIZENS, LEGENDS AND LOCAL DISASTERS

COLONEL GEORGE D. WICK, PROMINENT FIGURE IN LOCAL STEEL INDUSTRY, LOST ON *TITANIC*

Miriam R. Klein

Even though the RMS *Titanic* sank nearly a century ago, interest in the ill-fated ocean liner continues to capture imaginations.

The commercialization of the tragedy in a Broadway musical and director James Cameron's $200 million motion picture do not eclipse the tragedy of the twentieth century's most remembered maritime disaster. It is the real story and the individuals involved that continue to fascinate the public.

When the *Titanic* sank in 1912, Youngstown suffered the loss of industrialist Colonel George D. Wick. In an effort to restore his health, Wick had been touring Europe with his wife, Mary [Mollie] Hitchcock Wick, daughter Mary Natalie, their cousin, Caroline Bonnell, and Caroline's English aunt, Elizabeth Bonnell. [Among those lost at sea were sixteen people—out of thirty-six—traveling to Ohio.]

H. William Lawson, director of the Mahoning Valley Historical Society, said that Wick was an archetypal industrialist. "He was one of those capitalist types into just about everything," noted Lawson.

Colonel George D. Wick's father and grandfather were founding members of the Youngstown community and built the Wick family wealth from real estate and banking. Colonel George D. Wick and his partner, James Campbell, after earlier ventures in the steel-making industry, formed the Youngstown Sheet & Tube Company in 1900 with $600,000 in capital, added Lawson.

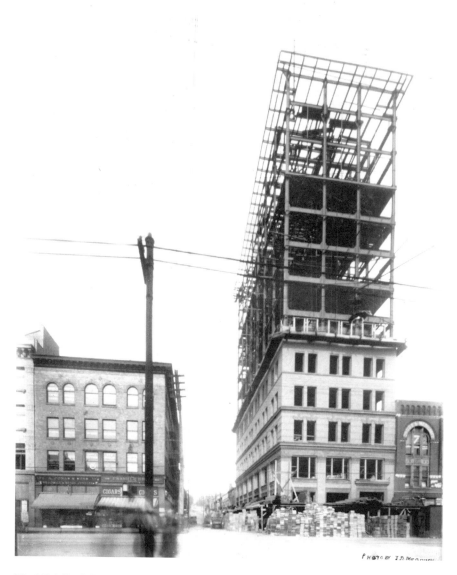

The Wick Bank Building under construction at the corner of West Federal Street and North Phelps on October 10, 1909. George D. Wick commissioned Chicago architect Daniel Burnham to design the building. *Photograph by J.D. Megown. Courtesy of Historic Images.*

Diana Shagla, a former assistant at the Arms Museum Library who maintains interest in the *Titanic*'s history, reported that Wick family members [now deceased] said, "Col. Wick possessed a very shrewd business sense and was highly respected. He always thought about the good of the city and did much charity work."

Shagla said the Youngstown community in general, and the Wick family in particular, deeply felt the loss of Wick, whose body was never recovered. His widow, Mary, wore darker-colored dresses and slowed her community schedule after her return to Youngstown.

The Wick family pew in the First Presbyterian Church was roped off and flags flew at half-staff. The mayor of Youngstown, Fred Hartenstein, forbade the showing of any films of the sinking ship in local theatres. In addition, for five minutes at 11:00 a.m. on April 24, 1912, all business in Youngstown ceased in his memory.

His widow, Mary Hitchcock Wick, died of influenza in 1920 at the family's Wick Avenue home. The residence, a red brick Georgian Revival structure, was completed in 1906. The building, which overlooks the Mahoning Valley and the city, is owned and maintained by Youngstown State University. The essence of the home's interior seems contained beneath the robin's egg blue paint; however, the flourishes of carved wood seats, bookcases and built-in cupboards hint at the exquisite elegance of the Edwardian Age.

The *Titanic*, which also dated from around this period, remains a consummate symbol of this era of delineated class distinctions and extravagant wealth, which may explain in part why the tragedy that befell it still fascinates many today.

On the bitterly cold evening of April 14, 1912, just before midnight, the RMS *Titanic*, making its maiden voyage, struck an iceberg that would take the ship and over 1,500 people with it to the bottom of the Atlantic Ocean.

It was the largest steamship ever built until that time—882 feet long and eleven stories high from keel to mast. The hull was black trimmed in white with four smokestacks trimmed in gold. It was said to be unsinkable due to the steel double hull and watertight flood compartments. It was also said at the time: "God himself could not sink the *Titanic*."

The *Titanic*, queen of the White Star Line, built in Belfast, Ireland, and designed by Thomas Andrews, sailed from Southampton, England, on April 10, 1912, with 2,227 passengers and crew.

Opulent and exclusive, first-class passengers enjoyed the best accommodations ever designed for a liner, including the first onboard swimming pool, a gymnasium, cafés and a card room. In contemporary dollars, a first-class ticket would cost $50,000. Even second-class

accommodations were better than first-class on other ships. Third class, nestled deep in the belly of the ship, was plain and practical.

The *Titanic* fascinated Janet White, a local writer and librarian, many years ago when her grandmother gave her a book about the ship. "I was very interested in the people," said White, adding that she was drawn primarily to the less wealthy, third-class passengers' personal histories.

She has researched the lives of several immigrants from this area who were on the *Titanic* in third class. She wrote the story of Finnish immigrant Elin Nummi in *I'm Going to See What Has Happened* with Nummi's son, the late Gerald Nummi of Warren.

"He wanted the story of his mother to be told," said White. The title of the book comes from the last words spoken by Elin Nummi's first husband, Pekka Hakkarainen. The couple was on their honeymoon. They felt the impact, and he left their berth to investigate; Elin Nummi never saw him again, added White.

White learned about two Syrian women who were coming to Youngstown and were also steerage passengers on the *Titanic*. Shanini Georges, returning to America from Lebanon after tending to an ill son, was among the many passengers placed on the *Titanic* due to a coal strike. The White Star Line, intent on showing off the most technologically advanced ship of their fleet and the world, took coal from other ships in order for the *Titanic* to sail.

After the disaster, Georges took twelve-year-old Banoura Ayout, coming to America from Syria and the sole survivor of her party, with her to Youngstown. White said she is still trying to discover what happened to Ayout, who was sent to live with friends in Columbus, Ohio.

The Wicks enjoyed the *Titanic*'s legendary, posh first-class accommodations. In an interview shortly after the sinking, Youngstown native and passenger Caroline Bonnell remembered the *Titanic* as a "floating palace."

In a first-hand account, Bonnell, on the night of April 14 at 11:40 p.m., recalled that she and Natalie, who were sharing a stateroom, heard "a rasping, tearing noise, but not impact."

Excited by the prospect of seeing an iceberg, the women dressed and went up on deck. Bonnell reported no fear among the passengers and that a mischievous few pitched shards of the iceberg at one another. The sailors were calm. Men in salons were reluctant to leave card games.

"Mr. Wick refused to believe at first there was any danger, but when we went below after we had been told to put on life belts, he had dressed and met us on deck. We were all rather unconcerned," Bonnell later told a reporter in New York.

On the upper deck, the Wick party met for the last time. Bonnell reported that they had felt no danger because they could not notice the listing of the ship. Many also thought that it would be safer to remain aboard the *Titanic* than to drift in lifeboats on the Atlantic.

"The sea was calm, the night cold and the stars shone," Bonnell remarked in accounts of the disaster shortly thereafter.

As the women in the Wick party recalled, Colonel George D. Wick helped them into a lifeboat, told them to keep up their courage and row to the light of an approaching distant ship.

Bonnell said that more people could have been placed in her lifeboat, which was the second to leave the ship. [The first lifeboat held only six people.]

Many of the lifeboats lowered ninety feet to the glassy sea had been filled with fewer than half of the sixty-person capacity. As accounts of the disaster have noted, the number of lifeboats on the liner fell far short of the need. Even though there were 2,227 passengers and crew onboard, there were only enough lifeboats for 1,700 people. Of the total on board, 705 survived.

According to an account given by Mary Hitchcock Wick to her sister, the late Mrs. Myron Arms, the castaway party of thirty watched the vision of twinkling lights disappear deck by deck until there was only a dark shadow of the stern lifted toward a crystalline, moonless sky.

About 2:20 a.m., April 15, the silent group heard the dreadful noise of explosions and the cries of agony from people attempting to swim in the twenty-eight-degree water. At dawn, the liner *Carpathia* rescued the lifeboat holding the remaining Wicks.

After the disaster, disabled victims and families left destitute by the loss of fathers and husbands sued the White Star Line for compensation. Many of the plaintiffs stated that the ship was navigated recklessly, and many widows said that their husbands were prevented from entering lifeboats. The famous call for "women and children first" had been interpreted to mean "women and children only" by some of the crew.

In 1985, in a joint effort between American and French deep-sea explorers, the wreck of the *Titanic* was found 2.5 miles below the surface of the Atlantic Ocean. Investigations of the wreck revealed that the vessel did not suffer a three-hundred-foot gash from the crash into the iceberg. The steel of the hull had become brittle in the frigid water. The iceberg, it is now thought, caused six four-foot slits along the starboard hull, and weakened rivets popped out along the ship's seam.

During follow-up expeditions to the site, the salvage company, RMS Titanic, Inc., recovered thousands of artifacts, including a silver tray, a beacon light, a brass cherub decoration and even papers.

DON HANNI: REMEMBERING MAHONING COUNTY'S BOMBASTIC DEMOCRATIC PARTY BOSS

Tom Welsh

Tom Welsh and Mark C. Peyko conducted the following interview in 1994 on the eve of Don Hanni's ouster as Democratic Party boss.

When Attorney Don L. Hanni Jr. was first elected Mahoning Valley Democratic Party chairman in 1977, the community was reeling from the loss of its steel industry. Diminished were the steelworker unions that had once supported the county's political "machine," and a mass exodus out of the Mahoning Valley left many of the party's working-class precincts depopulated.

Nevertheless, Hanni had become what his predecessors had never been—a celebrity. His bombastic style and personal and professional controversies had been recorded in the local and regional media. In the early 1990s, Hanni was even interviewed by Morley Safer of CBS's top-rated news program, *60 Minutes.*

But former Mahoning County commissioner David Engler was no fan. The then commissioner, in fact, had cited the party chairman as an obstacle to the Mahoning Valley's economic recovery—a stubborn remnant of an "archaic" political system.

In early 1994, Engler joined forces with Attorney Michael Morley and fellow Mahoning County commissioner Frank A. Lordi to establish Mahoning County Democrats for Change. During that time, the organization had recruited and filed nominating petitions for nearly four hundred candidates to represent the county's 418 Democratic precincts.

Since precinct committee members elect the party chairman, dissident Democrats viewed the committee as, perhaps, Hanni's last power base—one that had endured, they added, in spite of the decreasing value of the party's endorsement.

Furthermore, Morley, a then political newcomer with a private law practice, announced that he intended to run for the position of Mahoning County Democratic party chairman.

Hanni, characteristically, hadn't taken the challenge lying down. [In a 1994 interview, Morley said that Hanni dismissed the opposition as "yuppies" and "Republicans."] The chairman—ridiculing their charges of "boss-ism"—accused Morley, Engler and Lordi of acting out of personal ambition.

Don Hanni, Mahoning County Democratic Party boss, as emperor. Illustration by Tom Welsh for the *Metro Monthly*. *Courtesy of the* Metro Monthly.

In an article that appeared in the *Vindicator* on February 14, 1994, Hanni stated, "I am a Jacksonian Democrat, and I believe to the victor belongs the spoils. I've been in politics for just under 50 years and the one thing I have always abhorred about this outcry, 'we have to stop machine politics' is the hypocrisy involved. As the cliché goes, it all depends on whose bull is being gored."

The response was just the sort of confrontational, unapologetic one that area residents had grown to expect of the chairman. Engler, however, had suggested that Hanni's handling of criticism promoted "a climate of cynicism."

"His strategy of defense has consistently been to attack the credibility of his opponents. He knows that if you…[say it] big enough, loud enough and often enough people will believe it," Engler said in 1994. "And he gets away with it, leading people to think 'Hey, they're all rotten.'"

Hanni, on the other hand, termed himself "a straight shooter" and was quick to point out any inconsistencies he discerned between his opponents' words and actions.

Leafing through the then new Mahoning County Democrats for Change platform in 1994, Hanni shrugged. "This is process isn't it? When I was a younger Democrat, I was trying to push out older Democrats…That's the whole process, and I'm not opposed to it." The next line, however, was punctuated with a flailing hand. "I'm opposed to a guy who represents himself as something he's not—like this Engler, who's campaigning for state central committeeman."

He then turned to page six of the printed platform. "What's this?" He read: "No Endorsement of candidates in primary elections." Hanni laughed. "Well, here's a son of a b---- who has to go to Trumbull County a month ago…to have his name placed for consideration for the endorsement of the Trumbull County Democratic Party for the position of state central committeeman," Hanni claimed at the time. "This is what I'm opposed to. You can't be opposed to primary endorsements and then participate in the process."

Although the outcome of the political battle was unknown in early 1994, Hanni, along with then U.S. representative James Traficant, had defined Mahoning Valley politics for many state and national observers. In a field dominated by low-key, semicorporate figures, the chairman stood out like a Depression-era populist.

However, no one accused him of being boring. For nearly two decades, aided by immense personal charisma and a keen intelligence, Hanni had remained in place, despite a flurry of negative publicity.

Tales from the Mahoning Valley

In 1980, for instance, FBI agents obtained a warrant to search Hanni's farm in New Bedford, Pennsylvania, uncovering a twenty-four-foot sailboat allegedly stolen from a marina in Fort Meyers, Florida. Hanni insisted at that time that he had purchased the boat from a Fort Meyers watercraft dealer. The chairman later claimed the incident stemmed from a "domestic dispute."

In the mid-1980s, domestic differences were at the center of a more negative publicity when the chairman's second wife, Billie Jo Hanni, filed assault charges against her husband. Billie Jo Hanni, who had claimed that her husband allegedly assaulted her and their fourteen-year-old son, dropped all charges a couple of weeks later.

But 1985 witnessed what was to become the most celebrated incident involving the chairman. That was the summer that Hanni's car crashed into Youngstown's Main Post Office branch on South Walnut Street. Hanni was charged with driving while intoxicated. The following month, he was informed that his driver's license would be revoked for one year due to his alleged refusal to submit to a sobriety test. However, in August of that year, the Ohio Supreme Court found Hanni innocent of the drunken driving charge by a visiting judge appointed to hear the case. The following April, a Youngstown municipal judge revoked the one-year suspension on Hanni's driver's license.

Opponents in 1994, however, cited Hanni's interview with *60 Minutes* anchor Morley Safer most frequently. The segment, which spotlighted U.S. representative James Traficant, was nationally telecast on November 11, 1990. Asked by Safer how Hanni knew that Traficant had once accepted money from local mobsters, Hanni responded, "Because I know that everybody takes money from the mob. You don't take the money, you put them—them on the other side, and if you put them on the other side, they take all their people with them."

While Safer may have been delighted by the response, many local viewers were not.

Michael Morley was one of them. "To tell tens of millions of people across the country that Mahoning Valley politics is run in conjunction with the Mafia hurts civic pride…and badly damages our image outside of Mahoning County," Morley said, remembering the interview with a wince. "Statements like that create an attitude of tolerance. People think that's the way it is—and, consequently, that's the way it is."

Hanni—like the local Democratic Party itself—sprang from the scrappy environs of Youngstown's East Side. His parents, like many area residents, traced their roots to Europe. Hanni's father was of Swiss-German

background. His mother was an Italian American. Hanni grew up admiring then Mahoning County Democratic chairman John Vitullo.

But Hanni had insisted that his interest in politics came relatively late. Before serving in the armed forces during World War II, he was an amateur boxer. [His speech remained loaded with sports and military metaphors.] Ironically, Hanni's first taste of politics came as president of the "College Republicans" at what was then Youngstown College. He remained a Republican for two years.

After earning his law degree at Youngstown College in 1953, he taught school and served as principal at Springfield Local High School. Hanni became assistant city prosecutor before serving as a municipal judge from 1959 to 1965. He was an unsuccessful Youngstown mayoral candidate in 1969. Hanni has been married twice and has seven children.

The chairman's law office in downtown Youngstown, located directly above the Mahoning County Democratic headquarters, was filled with memorabilia of his nearly fifty-year political career. One black-and-white photograph showed a youthful Hanni sitting to the left of former U.S. representative Michael J. Kirwan in the old Idora Park Ballroom. To Kirwan's right sits 1960 presidential candidate John F. Kennedy. [Hanni was toastmaster that evening.] Another old photograph shows Hanni with former president Harry S. Truman. Hanni, who was instrumental in bringing Truman to Mahoning County in 1962, referred to him—in words reminiscent of Truman himself—as "the best goddamn president in the history of the United States."

But the ambitious young lawyer who advanced quickly on the political fast track was viewed by many area residents in 1994 as Mahoning County's entrenched political "boss."

Despite the movement against him, however, Hanni still had many supporters. Attorney Vincent E. Gilmartin, a longtime colleague, suggested that the chairman has been scapegoated by opponents for social and economic difficulties arising solely from the collapse of the area's steel industry. He added that Hanni's image as an omnipresent political boss was largely a media creation.

"I do think he's a 'hands-on' party chairman; but, I'll tell you, most people don't even know who the county chairman of the Republican Party is," Gilmartin said in 1994. "With a Republican in the governor's mansion, that's a position that wields quite a bit of power…Where is all the power and patronage they're talking about [in Hanni's case]? It seems to me that it's much ado about nothing."

View looking west on West Federal Street in downtown Youngstown, circa 1961–62. *Courtesy of Mark C. Peyko.*

Then North Side precinct committeewoman Alice Lev agreed. "The question of control is overplayed with the Democratic Party," Lev said. "It's difficult to be Democratic chairman in an area where there are no power magnates left—since the collapse of the steel industry and labor unions. It's not like the old days when there were lots of patronage jobs to give out...It was a different scenario."

Clingan Jackson, who had served as *Vindicator* political editor for nearly fifty years, saw Mahoning County Democrats for Change as "a healthy sign for the area." Jackson, who said Hanni "has the knowledge and capability to be an outstanding chairman or handle any public office," nevertheless suggested that any grassroots effort to recruit precinct committee members could only benefit both parties.

"It's this that citizenship ought to be about: to do something about both parties—not just here but nationally," said Jackson in 1994. "They need to be reformed, both of them. That starts right back with the precinct committees. A majority of precinct committeemen are people of slight account who hold state jobs."

Morley—who avoided singling out Hanni himself as the "problem" with county politics—concurred with Jackson's assessment. "We've been fortunate enough to recruit people who want to serve [on the precinct committee] for nonpolitical reasons," said Morley in 1994. "These are people who are looking forward to the opportunity to change things they've been complaining about or are embarrassed about."

One of those embarrassments, Morley added, was the area's long-standing reputation for corruption.

In 1978, Morley, a young law student, found out just how poorly the county was perceived by Ohio residents. One of his criminal law professors opened class by imparting his wish that his students would find what they learned useful when they returned to practice law in their respective counties. Then, remembers Morley, the professor paused. "Now, what I just said, of course, applies to those of you from eighty-seven of the counties in Ohio. Those of you who are returning to Mahoning County—you might as well forget everything you've learned here."

Hanni's perception of the county was, perhaps, different. He saw Mahoning County's Democratic Party as "the best organized in the state." After all, with the exception of George McGovern, the county had carried every Democratic candidate for president for the last thirty years.

While he sat behind his desk, a placard behind him reading "The Buck Stops Here," Hanni discussed issues well beyond the scope of the county: the injustice of a flat tax and the public's "obscene" penchant for building prisons instead of supporting employment programs.

However, the conversation turned, again, to his image. A few months earlier in 1993, *Plain Dealer* columnist Steve Luttner depicted the chairman as "a fire-breathing relic from the politics of another time." Opponents had accused him of supposed intimidation tactics and of being an "embarrassment" to the county. The mention of his very name often tended to elicit extreme reactions. "How does it feel when people say they hate you?" we asked in our 1994 interview.

"Well, your observation is absolutely correct," Hanni responded. "There are very few people who are neutral about me. They either love me, or they hate me. For the most part—and you may think this is braggadocios—the people that hate me usually don't know me."

THE FINAL DAYS OF YOUNGSTOWN'S PALACE THEATRE

Mark C. Peyko

Urban renewal brought tremendous change to downtown Youngstown in the 1960s. In the spring of 1965, the landmark Palace Theatre, a widely loved symbol of the city's glory days, became one of its most high-profile casualties.

To this day, many area residents—even those with only a passing interest in the city—recall with regret the loss of Youngstown's most celebrated performance venue.

The Palace Theatre was sited downtown near the northeast corner of Wick Avenue and Commerce Street. From the time it opened as the Keith-Albee Theatre in 1926, the vaudeville and movie house consistently brought the best in entertainment to the city. Glenn Miller and Tommy Dorsey played the Palace, and a young Frank Sinatra announced his plans to go solo from the theatre's stage in 1942.

In a 1998 article in the *Metro Monthly*, Youngstown resident Marilyn [Smith] Kane recalled the wild afternoon when she saw Sinatra perform downtown amid screaming girls and the din of crowd noise.

A pre-demolition auction at the theatre, by contrast, generated far less hysteria. In November 1964, the *Steel Valley News* reported that two hundred people attended an auction of the 2,800-seat theatre's furnishings and architectural features. Ohio Contracting, the firm hired to demolish the four-story downtown landmark, took various perspective photos of the Palace before demolition.

Across the United States, downtown movie palaces met similar fates. Although the popularity of television seriously affected theatre receipts, an antitrust ruling that forbade Hollywood studios from owning the movie theatre real estate proved devastating. This, combined with federally sponsored urban clearance programs, sealed the fates of many of the nation's downtown theatres. Others limped into the 1970s, temporarily propped up by kung fu movies and blaxploitation films.

In 1964, Stephen C. Baytos and Associates purchased the Palace Theatre property. At the time, public relations officer J. Kenneth Gran said that the firm had plans to demolish the theatre and replace it with a $3 million development called Plaza 1.

The project, which included a 1,200-seat Cinerama theatre, high-rise apartments and retail shops, was never built. A surface parking lot has occupied the site ever since.

The Palace Theatre in the early 1960s. Cryptic, hand-written notations ("Palace Wrecking Project" and "Ohio Contracting") on the reverse indicate the fate of the theatre. *Courtesy of Historic Images.*

TIME RUNS OUT FOR JEANNETTE BLAST FURNACE

Mark C. Peyko and John Rose

J. Richard Rowlands was four years old when the Mahoning Valley's steel industry collapsed, so it seems quite unusual that the Hubbard youth would have become so taken with the history of the local industry.

However, since founding the Jeannette Blast Furnace Preservation Association in 1992, Rowlands had become a lobbyist, activist and pilot for an organization with a noble, yet ultimately unattainable, goal: the preservation of the Jeannette Blast Furnace.

The Jeannette site was one of the last remaining vestiges of a once omnipresent industrial complex that stretched along the Mahoning River from Warren to Lowellville. With this in mind, the Ohio Department of Development's razing of the historic blast furnace and related buildings sent a crushing blow to the young man whose mission for Jeannette had, at times, become messianic.

In a 1993 article in the *Metro Eye*, Rowlands said that he wanted to transform the rapidly deteriorating Jeannette Blast Furnace at Brier Hill into

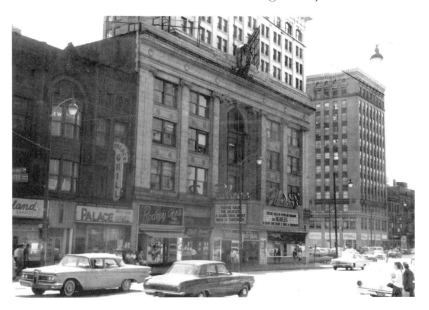

Looking southeast toward the Palace Theatre and Central Square in 1964. *Courtesy of Historic Images.*

View looking west from East Federal Street in downtown Youngstown in 1960. *Courtesy of Mark C. Peyko.*

Youngstown's Central Square, looking southwest, circa 1961–62. *Courtesy of Mark C. Peyko.*

a museum, where people could learn about the Mahoning Valley's historic role in America's steel industry by experiencing it.

"People my age and younger, I don't think they would know much about it [the mills]," Rowlands noted at the time. "Most of it [research material] is hidden; that's one reason why it was really important to help educate."

With the assistance of his sixty-member Jeannette Blast Furnace Preservation Association, Rowlands had hoped to acquire, secure and stabilize the Jeannette site. Rowlands, who had been handling ongoing negotiations with the state of Ohio, said that the association "couldn't do what they [the state] needed for us to do, so we decided to direct those resources to things that we could manage."

Youngstown resident Bryn Zellers, another member of the association, said that conditions from the state that the group carry a large insurance policy, undertake a below-ground cleanup and stabilize the Jeannette structure were not feasible for the association.

"If we continued with the blast furnace, we could lose everything else," Rowlands said. Instead, he negotiated to videotape, photograph and document the doomed Jeannette complex, which was immortalized by Bruce Springsteen in the song "Youngstown." Although the documentation

scenario was far from the fate that Rowlands had envisioned, it's probably the best the group could do considering the circumstances.

The Jeannette Blast Furnace dated to 1917, the year the United States entered World War I. In anticipation of a heightened need for steel, the Brier Hill Steel Company began building the furnace plant that same year. Blast furnaces play an essential role in the steel-making process. They are basically extremely hot structures that remove the carbon content from iron. Only after this removal can the iron be used as material for steel production.

The Jeannette Blast Furnace, named after the daughter of the Brier Hill Company president, began production in September 1918—only two months before World War I ended. After its only upgrade in 1924, the furnace ran with occasional interruptions until 1977, having produced a total of 2.6 million tons of iron suitable for steel production.

"A lot of people called it the best-running blast furnace," Rowlands said.

After suffering from years of deterioration and looting, the last remaining furnace plant in the area was discovered by Rowlands, who had been exploring the Brier Hill area when he was a teenager. Since that discovery, much of Rowlands's time had been spent trying to save the furnace. "That first year I really crammed to learn the steel-making process," said Rowlands in 1993. "I must have checked out every book from the library."

The result of all this early work had been the formation of JBFPA and a planned, four-phase proposal for the furnace's restoration. In that plan, an ambitious furnace-plant museum would have included indoor exhibitions, historical accounts of Youngstown Sheet & Tube and rolling stock donated by the Mahoning Valley Railroad Heritage Association and others. The rolling stock would have included a hot metal car, slag car, scale car, steam locomotive and other equipment associated with the steel and railroad industries.

Another person who had believed in JBFPA and its core mission was H. William Lawson, director of the Mahoning Valley Historical Society. In 1993, Lawson noted that museums displaying exhibitions about the steel industry, such as the Youngstown Museum of Industry and Labor, could never completely replace seeing the real thing. "There's something that's romantic and mythical to what those people [steelworkers] were doing," he said, "and you can't give an accurate presence of that under a roof."

Dr. Donna DeBlasio, then director of the Youngstown Museum of Industry and Labor, agreed. She said that the preservation of the blast furnace could have complemented the industrial museum's exhibitions. "It's the only blast furnace in the area, and we obviously can't put it in the museum."

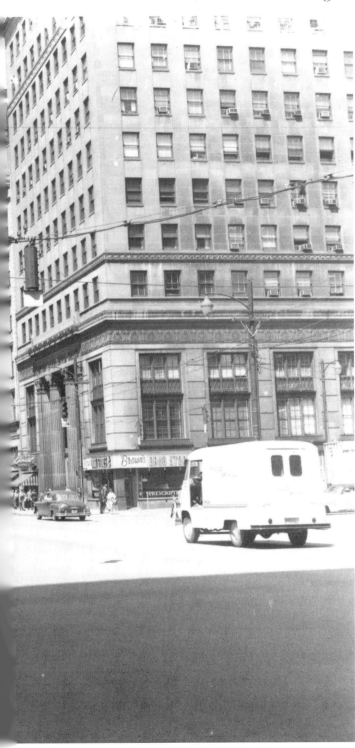

View looking west toward West Federal Street from Central Square in 1960. *Courtesy of Mark C. Peyko.*

This postcard image depicts the Market Street Viaduct in the early 1920s. Downtown Youngstown is seen in the background. *Courtesy of Mark C. Peyko.*

On the loss of the Jeannette site, Lawson added:

> *In terms of our short-term drive to recoup the jobs lost 20 years ago in the steel industry, we are obliterating examples of the past such as Jeannette. It will be hard for future generations to understand the scale of the industry and how important it was to this community. I don't think we can fully appreciate how it [the steel industry] affected both the economic and physical landscape of the Mahoning Valley without having structures like Jeannette to see.*
>
> *That plant gave the whole aura of the industrial town. By losing the mills, we've lost an aesthetic component of the area—not to mention jobs.*

PART V

ARTS, COMMUNITY AND CULTURE

STAMBAUGH AUDITORIUM, A PHILANTHROPIST'S GIFT TO THE PEOPLE OF YOUNGSTOWN

Mark C. Peyko

Stambaugh Auditorium, site of countless concerts, graduations and religious revivals, was rededicated in September 2005 to mark the completion of extensive restorations. The ceremony included a special performance by the Youngstown Symphony. The orchestra performed classical and popular music and featured guest conductor Randall Craig Fleischer and vocalists Jodi Benson, Debbie Gravitte and Stephen Buntrock.

The restoration was the climax of nearly twenty years of renovations and repairs to the cultural facility. In 2001, Anna Jean Cushwa, president of the Henry H. Stambaugh Auditorium Association Board of Trustees, said that trustees had spent approximately $3 million over a ten-year period to bring the facility up to code and preserve it for future generations of Mahoning Valley residents.

"National musical acts and political figures, religious revivals and camp meetings all occurred there. It's rare for a community of our size to have a facility like Stambaugh Auditorium…It's acoustically perfect, a true public music hall and auditorium," said Bill Lawson, director of the Mahoning Valley Historical Society.

Stambaugh Auditorium is arguably the most important public building in the region. While its opulence is apparent to first-time visitors, trustees added some unseen modern amenities to make Stambaugh competitive as a facility. Modernizations included the installation of a new stage lift and

a computerized box office. However, the most obvious difference was the replacement of aging red nylon "double-foam" chairs with seating in a regal sapphire blue.

"It [Stambaugh] sat there for at least fifty years without anyone doing anything to it," said Cushwa in 2001. "We started with the roof," she added, referring to a 1990 replacement project that cost $245,000 and utilized fifteen tons of copper membrane. Next came the updating of the structure's original electrical wiring, plumbing and windows. Trustees added amenities lacking in the 1926 building, most notably air conditioning and barrier-free access. The association equipped the ballroom area with a large kitchen to encourage bookings for wedding receptions and private parties.

State grants and private donations funded new stage lighting, garden renovations, stonework, elevator repairs and the rebuilding of the auditorium's marquee. In 2000 and 2003, trustees hired carpenters to restore the monumental window grilles on the southern and western portions of the building.

Stambaugh Auditorium was created through a gift from the estate of Youngstown industrialist Henry H. Stambaugh, who died in 1919 at age sixty. Stambaugh was a founder of the Brier Hill Steel Company and served as director of Youngstown Sheet & Tube Company for twelve years. Besides having vast real estate holdings in Youngstown and three large farms, Stambaugh had an interest in the Stambaugh Building in downtown Youngstown and was an organizer of the Realty Guarantee and Trust Company. He held directorships at a number of local banks and industrial concerns.

Stambaugh was born on November 24, 1858, in Brier Hill and was the son of John and Caroline Hamilton Stambaugh of Youngstown.

In a 1919 newspaper article on Henry H. Stambaugh's bequests, the *Youngstown Telegram* noted that after specific family gifts "the residue of his estate [will] be used for the purchase of a site and erection of an auditorium for Youngstown." In addition, Stambaugh bequeathed $50,000 to the Youngstown Foundation for the advancement of local charities and community institutions. Some beneficiaries included the Fresh Air Camp, the city's playground association, the Rayen School and the Reuben McMillan Free Library.

"In its seventy-five-year history, it [Stambaugh] has been a true convocation center for the community," said Lawson in 2001. Perhaps in more ways than most people realize. Like the Youngstown Convocation Center [Chevrolet Centre], early plans for Stambaugh Auditorium were met with intense public criticism and editorial opposition.

From its initial planning, site selection, excavation and construction, controversy swirled around the memorial auditorium. In a 1925 letter to the editor, the president of the board of trade complained that the proposed building was too far from the central business district. Newspaper articles from the mid-1920s revealed court-ordered work stoppages and political power plays. There was even a public meeting in the spring of 1925 at which Youngstown residents could voice their opinions, pro and con, on the proposed site.

Many times the public confrontations put Stambaugh trustees on the defensive. In 1925, acting spokesman John Stambaugh defended the proposed site before the city planning commission: "A building of the kind we are erecting needs free spaces, a background and perspective. The site we have chosen offers all these with Wick Park in the front and lawns around the whole building." In addition to lofty language, Stambaugh admitted to favoring the proposed site due to the affordability of the North Side parcels [at $50,000].

Harvey Wiley Corbett of the New York–based architectural firm of Hemle and Corbett designed the 2,554-seat auditorium in the classical style. Constructed of Indiana limestone, Stambaugh Auditorium cost approximately $1.8 million. Other prominent features included a lecture room, known today as the Marble Room, and an exhibition hall [the ballroom].

Despite earlier controversy, anticipation began to build as the Henry H. Stambaugh Memorial Auditorium neared completion. Strouss-Hirshberg's hailed the opening of Stambaugh Auditorium in its store advertising "as the most important event on the social calendar of Youngstown for some time." One ad from 1926 promoted "luxurious evening wraps" from $175 to $250 at a time when the average laborer in Youngstown earned $1,715 annually. However, the auditorium's opening ceremony and official dedication on Sunday, December 5, 1926, was free and open to all in the community.

American humorist Will Rogers appeared the following day as the first featured performer of Monday Musical Club's 1926–27 "Artist Concert Course." Rogers' well-received appearance resulted in three encores. During the third encore, he stretched out in the middle of the auditorium stage and snored loudly as the curtain fell.

Over the years, distinguished guests ranged from first lady Eleanor Roosevelt and 1960s presidential candidate Senator Hubert Humphrey to evangelist Kathryn Kuhlman. In the mid-1990s, Bruce Springsteen performed "Youngstown"—his haunting elegy to the collapsed local steel industry—to a hushed room. In addition, Stambaugh Auditorium has hosted countless high school proms and graduation ceremonies and scores

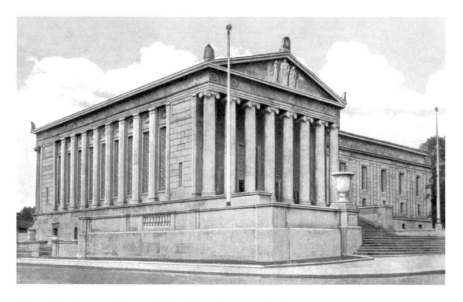

This undated postcard image depicts Stambaugh Auditorium on Youngstown's North Side. *Courtesy of Mark C. Peyko.*

of charitable events. Esther Hamilton's "Alias Santa Claus Club," too, was a holiday staple at Stambaugh for years.

"Stambaugh understood his philanthropic responsibilities and carried them out," Lawson said, adding that Stambaugh was friends with another noteworthy local philanthropist, Joseph Butler Jr., the founder of the Butler Institute of American Art.

BUTLER INSTITUTE WAS FIRST MUSEUM DEVOTED TO AMERICAN ART

Tom Welsh

The late Joseph G. Butler III often recounted a pleasant childhood memory involving his grandfather, Joseph G. Butler Jr., founder of Youngstown's Butler Institute of American Art.

Joseph Butler III, who served as the museum's director from 1934 until his death in 1981, remembered once being called out of his first-grade classroom to meet his grandfather, who was waiting outside. The old man, wearing his trademark black topcoat, greeted his grandson, turned to a carriage that was parked nearby and casually rapped on its door with his walking stick.

Suddenly, before the schoolboy's disbelieving eyes, the carriage door swung open and out jumped legendary Wild West showman "Buffalo Bill" Cody, accompanied by four Native Americans in full ceremonial regalia.

According to the grandson, this elaborate gesture of affection was typical of the Pennsylvania-born industrialist who, in 1919, established the first museum exclusively dedicated to American art.

Since its founding, the Butler Institute of American Art has long outgrown its erstwhile reputation as "America's best-kept secret" and is taking its rightful place as one of the finest institutions of its kind—not to mention the first.

Dr. Louis A. Zona, who has served as the institute's executive director since 1981, has overseen a number of expansions at the museum. The Butler added a $2.75 million addition to the south side of the building in 1996. The three-story, sixteen-thousand-square-foot expansion houses a national center for the study of American art and a gallery showcasing technology-based art. Construction began less than a decade after the completion of Beecher Court, the $4 million western wing that virtually doubled the size of the building. Other additions to the original structure over the years have included the construction of wings on the north and south side of the building in 1931 and the installment of additional second-floor galleries in 1967. In addition, a sculpture garden and terrace were added to the building's west end. The institute, which now holds roughly eleven thousand works within its permanent collection, also has branches in Salem and Howland.

Few would have predicted these developments when the Butler first opened its doors in October 1919. At that time, virtually no one acknowledged such a thing as "American art." Consequently, Joseph Butler Jr., who was fascinated with the American West, proved to be a pioneer in his own right.

The Butler's rise in national—and international—prominence, said Zona, parallels the meteoric rise of American art itself as a leading creative force. While the works of American artists are now desperately sought by museums throughout the world, many of these same works were once disparaged—by European and American critics alike—as "pale imitations of European movements."

"Americans were traditionally perceived as entrepreneurs and technicians," Zona explained. "But painters? No way. That just wasn't considered to be what America was about."

A shift occurred in 1916, following New York City's celebrated Armory Show, which exposed many American artists to the work of avant-garde Europeans. These artists aggressively tackled European concepts—such as Cubism, Expressionism and Dada—and applied them to creative interpretations of American's industry-based lifestyle.

Soldiers' Monument at Public Square, Youngstown, O.

This postcard image from 1913 depicts the Civil War monument on Youngstown's Central Square. *Courtesy of Mark C. Peyko.*

This trend was fueled in the 1930s, when the rise of Nazi Germany sparked an exodus of European artists and theorists to American metropolitan centers—including New York City, which would supersede Paris as international art capital following World War II.

Nevertheless, as late as the 1950s, the New York–based Whitney Museum would thoughtlessly sell off its entire collection of nineteenth-century American artwork. Happily, however, American artwork predating the Armory Show has since enjoyed a positive reevaluation.

Although Joseph Butler Jr.'s decision to build his museum long preceded many of these developments, Zona praised the founder as a sophisticated collector whose early purchases remain central to the institute's collection.

Among these is the Butler's most famous—and best-loved—acquisition: Winslow Homer's *Snap the Whip*. Decades after first spotting the painting at the 1876 Philadelphia Centennial, Joseph Butler Jr. purchased *Snap the Whip* for $5,000—the highest price paid for a Homer up to that point.

Zona noted that the founder's acuity as a collector was shared by his son, Henry Audubon Butler, and grandson, Joseph Butler III, who consecutively served as directors after Joseph Butler Jr.'s death in 1927.

During his seven-year tenure, Henry Butler oversaw the purchase of John Singer Sargent's *Mrs. Knowles and Her Children*—a popular favorite. Among the many significant purchases approved by Joseph Butler III was that of Albert Bierstadt's Western masterpiece, *The Oregon Trail*.

Ironically, however, it was the destruction of an art collection that first inspired Joseph Butler Jr. to establish a museum strictly dedicated to American artwork.

Born in Temperance Furnace, Pennsylvania, in 1840, Joseph Butler Jr. was raised in Poland, Ohio, and went on to become a founding partner in the Youngstown Sheet & Tube Steel Company.

An avid art collector since his young adulthood, Butler had by the mid-1900s assembled an impressive collection of contemporary European and American artwork. These works were displayed on the second-floor gallery of his North Side mansion—one of two houses then located on the current site of Youngstown State University's Bliss Hall.

One evening in 1916, while Butler was away on business in New York City, a fire broke out within the newly installed furnace of the Wick Avenue home, destroying the bulk of the art collection.

The only remnants of Butler's collection to survive, in fact, were roughly a dozen oil portraits of Native Americans. These paintings, which had been on display at Youngstown's Reuben McMillan Public Library, later served as the core of the Butler's Western collection.

While devastated by the loss, Butler was determined to rebuild his collection—this time strictly limiting his purchases to American artwork. Furthermore, the seventy-year-old industrialist hired the New York–based architectural firm of McKim, Mead & White to design a fireproof building in which to house the works.

Butler had only recently commissioned the same prestigious firm to design a memorial structure dedicated to his childhood friend, President William McKinley. The memorial, which still stands in downtown Niles, is yet another monument to the boundless energy of Joseph Butler Jr.

"I think that's one of the most fascinating things about my great-grandfather," said Lorinda Butler in a 1994 interview. "He had his fingers in so many pies…and he was from all accounts, a genuinely kind man, a true philanthropist with no ulterior motives."

Lorinda Butler noted that Joseph Butler Jr.'s prestige and influence were by no means limited to the Mahoning Valley. The industrialist once served as executive director of the American Iron and Steel Institute, a national organization dedicated to the promotion of steel products.

Toward the end of World War I, Butler headed the so-called Industrial Commission to France, a group of American business leaders who visited the war-ravaged nation and developed strategies for rebuilding its industrial base.

As a founder of the Mahoning Valley Historical Society, Butler also was a prolific author, who compiled histories of the regional steel industry and the immediate area. His three-volume *History of Youngstown and the Mahoning Valley*, published in 1921, remains a useful resource for students of local history. Joseph Butler Jr.'s autobiography, *Recollections of Men and Events*, was published in 1927.

According to the founder's great-grandson, Josh Butler, Joseph Butler Jr. attempted to instill "democratic ideals and a sense of civic responsibility" in his children and grandchildren.

Henry Butler, for instance, financed the construction of what is now Butler Memorial Presbyterian Church [located on the corner of Walnut Street and Rayen Avenue] as an angry response to the exclusion of African Americans from his own congregation at the First Presbyterian Church.

Mrs. Lucius Cochran recalled that, following Henry Butler's death, his widow, Grace, promoted ethnic art shows at the Butler in order to reach out to the community's large immigrant population. Cochran, who has connections to the Butler family, also noted that Grace Butler was instrumental in the establishment of the area's International Institute.

It was Joseph Butler III who, in 1937, established the Butler's annual Midyear Show, which continues to provide much-needed exposure for

regional artists. Three years later, the director hired area artist Clyde Singer [fresh from studies at New York's legendary Art Students' League] to supervise art classes geared to the general public.

Singer, who served as the Butler's curator of collections, recalled those days fondly in a 1994 interview. "I started off as what you'd call an artist-in-residence," he said. "But I eventually helped Joe Butler make purchases for the permanent collection—and, during that time, the museum collected some of the finest American painting you'll find anywhere. [Joseph Butler III] focused primarily on building up the collection. I think it was always understood that the building would need to be expanded."

Zona, during his tenure as executive director, has overseen the building's most dramatic expansion since its construction in 1919. The director noted in 1994 that despite the Youngstown area's economic difficulties, local fundraising drives for the Beecher Court addition yielded double the institute's preferred goal of $2 million.

"One consultant told us, at the time, that we'd be lucky to raise $200,000," Zona recalled, shaking his head.

In an effort to update and diversify the museum's outstanding permanent collection, Zona has coordinated the purchase of works by contemporary American artists—such as Andy Warhol, Helen Frankenthaler, Philip Pearlstein and Chuck Close.

Apart from these developments, efforts to promote the museum across the nation bolstered the Butler's long-deserved reputation as a cultural treasure. In 1993, master works from the collection appeared at the New York–based IBM Gallery, where they received critical acclaim.

But the museum's attributes have also been promoted through more accessible venues. The Butler's seventy-fifth anniversary, for instance, was duly noted on ABC's popular talk show *Good Morning America*.

Along the same lines, Zona has encouraged aggressive outreach strategies aimed specifically at area residents. He noted that the Butler's most successful show in recent years, The Artist at Ringside, was designed to appeal to the community's many sports fans. "It's one of our priorities to make the average person feel at home," Zona added.

The needs and concerns of the average person seemed to be very much on the mind of Joseph Butler Jr. Not long before the founder's death, he penned the following words: "In addition to providing for his descendants, every man of wealth owes something to the community in which he has lived."

Today, one wonders if even Joseph Butler Jr. could have foreseen that a community once famous for its steel products would become better known for *Snap the Whip*.

BRIER HILL: PORTAL TO A
BETTER LIFE IN AMERICA

Marie Shellock

The sweet, pungent smell of tomato sauce bubbling on a stove. The yeasty aroma of bread dough rising in a warm kitchen. The rhythmic thud of a knife chopping green peppers into slender strips. The taste of pizza hot from the oven.

These are some of the sense-tingling delights of harvest time in the Brier Hill homes of Italian immigrants of yesteryear.

The Italians who moved to Brier Hill on Youngstown's northwest side enjoyed garden produce that included lush tomatoes, peppers, onions and garlic. The harvest was the result of hard work based on know-how that they brought with them from Italy, which they often called "the old country."

The gardens gave forth abundance in most years, providing hearty meals for the families who lived in modest wood-frame houses in Brier Hill. Immigrants thought of their way of life as "making do" with what they had. They looked to the future—and their children's futures—for the promise of better days.

Brier Hill was a community that thrived on the gentle slopes above the mills that provided a living for immigrant families beginning in the 1800s. In the early days, the industry was coal, but it later became steel as the young United States built its infrastructure.

Although many people—including those who grew up there—would debate the exact boundaries of Brier Hill, a rough outline includes: Girard city limits, the old Federal Street [now Martin Luther King Boulevard], Wirt Street and Worthington Street.

Although Italian immigrants were the most populous European ethnic group to live in Brier Hill, it also was home at times to emigrants from Wales, Germany and other lands. African Americans from the South also have lived there.

Many of the local Italian immigrants were originally from towns in southern Italy, especially Basilicata and Calabria, according to the website of St. Anthony Parish.

Brier Hill was a convenient neighborhood for millworkers because they could easily walk to work. Even after personal automobiles became available, many people didn't have them.

Carl Barbone lived on Dearborn Street from 1925 to 1954.

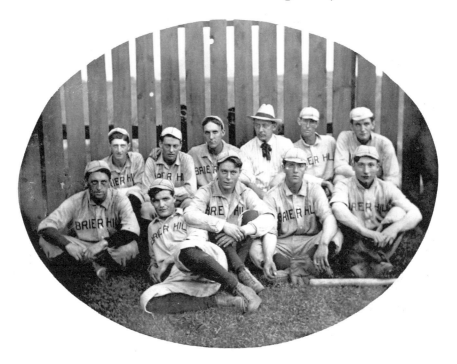

The Brier Hill baseball team poses for a photograph on September 27, 1906. *Courtesy of Historic Images.*

"People didn't have transportation, so they moved close to the mill and walked to work," recalled Barbone. He is one of thousands who have moved out of the neighborhood but return every year to catch up with old friends and neighbors during the annual Brier Hill Festival.

Dr. John B. Russo, a professor at Youngstown State University who studies working-class life and culture, has attended the Brier Hill festivals as part of research into the Mahoning Valley. He is co-author, with Dr. Sherry Lee Linkon, another YSU professor, of *Steeltown USA: Work and Memory in Youngstown*, which was published by the University of Kansas. They are co-directors of the YSU Center for Working Class Studies.

The book uses the history of Brier Hill to introduce various chapters on the history of the city. Russo said that the neighborhood's importance exists in the spirit of the people who stuck together in hard times for their mutual survival.

"It was about making do in very difficult times—coming together as a community. What they developed here was a very strong sense of community," Russo said. He described Brier Hill as "a portal community"—that is, one that immigrants settled in upon arriving in a region.

As an example of making do in face of adversity, Russo offered the example of Brier Hill pizza—a regionally known pie with tomato sauce, peppers, onions and a sprinkling of grated hard cheese.

"Take a look at a Brier Hill pizza. What's a Brier Hill pizza? Basically… things that could be home grown. It has a sprinkling of cheese. They didn't have [much] money for cheese. They just put a little bit on it," Russo explained.

Russo has found that the Brier Hill Festival has pulled thousands from suburbs in the Mahoning Valley and well beyond for more than a decade.

"Even after they left this community and moved out into the suburbs, many tried to recreate what they had here in the Brier Hill Fest," Russo said. "Part of its themes have been 'the spirit of the old neighborhood.' So what they're trying to remember are those things that they felt when they knew everybody on the street, and you took care of everybody and watched for everybody. In the best sense, that's what it meant in terms of community."

Held annually in mid-August on the narrow roads at the corners of Calvin and Victoria Streets, the festival features Italian food and music, as well as bocce, an Italian game that has been played since the Roman Empire.

Joe Naples, who has served as festival co-chairman, said that the ground that the festival covers is deliberately kept small in order to foster a sense of intimacy among attendees, many of whom know each other from the old neighborhood and enjoy intermingling.

In August, many attendees also participate in a procession and Mass in St. Anthony Church on the morning of the final day of the festival. The Reverend John H. DeMarinis, St. Anthony pastor, said that the festival reminds Brier Hill natives and descendants of the values by which their families flourished. Using his own family as an example, he said in his Mass homily on August 19, 2001: "Today we hear about the work ethic. My grandfather never heard of that—the work ethic. He actually lived it without ever hearing about it."

He said that his grandfather worked a twelve-hour shift in a steel mill to feed his family, who never went hungry, and took pride in everything he did from his foundry work to his garden to his winemaking. He said that his family, which belonged to Immaculate Conception Parish on the East Side of Youngstown, was similar to the families of Brier Hill in that they left a strong legacy for their children.

DOWNTOWN FROM THE SEVENTH FLOOR OF THE REALTY BUILDING: RECALLING LIFE IN 1940S YOUNGSTOWN

Lee Meadows

The year is 1946. I am on the seventh floor of the Realty Building, where I worked as a receptionist in the Department of Industrial Relations.

I'm looking out the window to the hustle and bustle of downtown Youngstown. Traffic is circling around Central Square and up and down Federal Street, which was open to traffic at the time. As I watched all this, I had no idea that the downtown area would some day give way to progress.

My memories are many. Some of the most vivid are when downtown Youngstown was where it all was happening—the office buildings, the department stores, the five-and-dimes and the specialty shops for men and women. The many restaurants, movie houses and banks. It was a very special place at that time.

We had the most beautiful and unique theatres. The Palace, Paramount, State and the Warner [Powers Auditorium]. Each theatre had remarkable interiors, ornate and grand. But of all the theatres, the Palace stands out in my mind because as a young girl I went there to see Frank Sinatra, Tommy and Jimmy Dorsey, Glenn Miller and others. There were many musicals—like *Annie Get Your Gun*. It was all so exciting, and everyone went! We were known to sit in the theatre aisles because it was so packed. I doubt that I could ever forget those special moments.

After the performance, we went next door for sodas at Friedman's. When we went to the Paramount Theatre, we always stopped at Fanny Farmer Candies before the movie. Such delectables!

Of course, the shopping was great. Strouss-Hirshberg's and McKelvey's were the major department stores, and for the women, Livingston's was the place. Livingston's had beautiful selections and a beautiful decor. I remember buying all my clothes for my honeymoon there. And a frosted malt was a must when shopping at Strouss-Hirshberg's. We never missed an opportunity to have a malt; it was part of our shopping experience.

Let's talk about dining. The Italian Restaurant was a must. On the lighter side, there was the Purple Cow. And last, but not least, the elegant Mural Room—where we went to dinner before going to see Mantavoni at Stambaugh Auditorium.

Looking east from the corner of North Hazel and West Federal Streets in downtown Youngstown in the late 1930s. The Paramount Theatre's marquee is seen on the left. *Courtesy of Historic Images.*

In those days, "going downtown" meant getting dressed up in your Sunday finest. We sometimes wore hats and gloves, which seems formal compared to today's casual attire. And there was always a roving photographer snapping your picture as you walked along Federal Street—a memento of a lovely day downtown.

My most vivid memory of downtown was the day World War II ended. The town went wild, and we all tried to get to downtown Youngstown to celebrate. Most of us walked, no matter where we lived in town, because the busses had stopped running—they just couldn't keep up with the crowds. The downtown area became our own Times Square on New Year's Eve. Everyone was hugging, kissing and crying. The emotion was electric. We cheered for our victory and our boys who would be coming home, and we cried for so many of our boys that had fought so bravely and died for our country.

For those too young to remember, downtown Youngstown was part of another time, in a bustling place...sadly missed.

"Miss Network Difficulty" Calmed the Troubled Airwaves in the 1950s

Christine Davidson

Back when Susie Sidesaddle captivated kiddies and Marge Mariner [the Mahoning Valley's Martha Stewart] tantalized Youngstowner's taste buds, an unlikely nineteen-year-old woman reigned over the local airwaves for one year.

Doris Mraovich won the title of "Miss Network Difficulty" in May of 1955 and started a broadcasting career that spanned more than four decades.

During her brief burst of fame, Mraovich appeared on Dave Garroway's *Today* show on NBC. Her picture blazed across the front page [above the fold] of the *Youngstown Vindicator*, and there she was dead center in the September 1955 issue of *Pageant* magazine, admonishing readers, "Wait! Don't Turn that Dial." She was even featured in the *New Yorker*.

WFMJ TV's Susie Sidesaddle makes a celebrity appearance at Idora Park. *Courtesy of Historic Images.*

As her title implied, a picture of Doris Mraovich would pop up on WFMJ whenever storms, power outages or other troubles interrupted the signal from the NBC network to its affiliates. That happened a lot in the early days of television. And since disruptions frequently caused viewers to turn off the set rather than watch snow, WFMJ decided to give the viewers something to look at—that something was Doris Mraovich in Bermuda shorts, halter top, white high heel pumps and a scarf tied around her waist.

In poses reminiscent of the World War II pinup girls, Mraovich held props for the various program genres that might have been disrupted: a smoking gun for a mystery; a cookbook for a cooking show; or a holstered gun and cowboy hat for a western. Each of the pictures had an appropriate caption. Mystery: "No mystery about this…the network's shot." Cooking: "Please don't get burned up…we'll be cooking again in a moment." Western: "Don't move, pardner…we'll be back on the trail in a moment."

Seven of Mraovich's pictures ran in *Pageant* magazine. The accompanying text noted:

> *No more jumpy lines and fog for viewers around Youngstown, Ohio. Station WFMJ there picked a Miss Network Difficulty from 500 pretty girls, posed her to match the mood of interrupted programs. Now, when technical trouble hinders a telecast, they quickly flash on Miss N.D. Result: nobody wants the show back.*

Hank Perkins, who worked at the *Youngstown Vindicator* and WFMJ, photographed Mraovich one night with the help of the program director, Warren Park, and his wife. "You can see what a dinky outfit that was and I was real flat chested and she [Park's wife] said come here and she took me into the ladies room and she stuffed my bra with toilet paper," recalled Mraovich. "And then I had these dumb shoes and she said, 'put mine on.' Well, I'm a size nine shoe and she's a size seven so I was in pain and agony, you can see how small they look on me…they were tiny…white high heels. Then when I came out Hank said, 'that's good…that's real good.'"

Mraovich's career started when her mother submitted her daughter's graduation picture for the WFMJ promotion. The competition garnered coverage in the *New Yorker*'s "Talk of the Town" section in May 1955. The magazine noted:

> *The contest is being conducted not too far from the nation's breadbasket in an around Youngstown, Ohio. Once Miss Network Difficulty is elected, she will be shown photographed in a variety of poses, to the television*

audience in that area by station WFMJ-TV during those ugly gaps that heretofore have been baldly stuffed by an admission of temporary defeat and an imploring whine—"We have lost the network picture, please stand by." The formless vision misplaced in the heavenly waves over Youngstown, the curves of beauty discovered in the race for earthly fame. From every angle, whoever you turn out to be, we'll love you all through the summertime and even after the leaves have fallen, dear Miss Network Difficulty.

According to the June 5, 1955 *Youngstown Vindicator*, more than twenty thousand Channel 21 viewers cast ballots for Mraovich to win the title.

Mraovich recalled her appearance on the *Today* show with Dave Garroway. "Here I was Little Miss Nobody and here's this Big Guy, the Guy, being so nice to me trying to calm me down." In those pre-videotape days, *Today* re-interviewed guests for each different time zone. Mraovich said she was so nervous for the third and final interview that Garroway had to coax her out of the green room.

Garroway's charm and charisma had a profound effect on the young woman. "I decided right then, I wanted to be in television, live TV, not on the air [her lip twitches when she's in the spotlight] but behind the scenes." She did just that. After her year as Miss Network Difficulty, Mraovich continued behind the scenes first at WFMJ and later at WKBN. She retired from WKBN in 1999 after forty-five years.

As it turned out, Mraovich was the one and only Miss Network Difficulty. "Miss Network Difficulty was one year, I only reigned one year," Mraovich said. "And then I was glad they never did anybody else because that was my one and only shot, and everybody will remember there was only one, so I was glad when they decided not to do it."

Flash to today. A short while ago, an old black-and-white movie played on Turner Classic Movies (TCM). The movie suddenly halted; instead of a picture of Doris Mraovich, the words "Unstable Signal" crawled across the blue screen. Sometimes progress is not progress at all.

PART VI

MAHONING VALLEY ICONS

VOLNEY ROGERS CREATED MILL CREEK PARK FOR ENJOYMENT OF FUTURE GENERATIONS

Rebecca Dale

Mill Creek Park. Just try to imagine Youngstown and its suburbs without this cool green oasis, its miles of hiking rails, Sunday nature walks, children's programs, picnics and boating. Then thank Volney Rogers, the man who not only preserved this nature treasure but also influenced the very direction in which Youngstown developed, improving the quality of life in our valley far into the future.

Now imagine yourself as a citizen of Youngstown over a century ago, born perhaps in 1870. Rogers, having grown up amid the natural beauty of Columbiana County, was studying law in Mount Gilead, Ohio. By 1872, when Rogers opened his office in Youngstown, you would be a toddler, bewildered by dusty, noisy streets, choking on smoke from the mills and threatened by typhoid from unsanitary conditions and polluted water. Rogers himself fell seriously ill during his first summer in the city.

He sought respite in nature, riding on horseback into undeveloped areas outside the city limits. At this time, Rogers discovered the Mill Creek Gorge. He saw how city dwellers like you might enjoy better mental and physical health if such fresh air and natural beauty were preserved. But by 1890, the land was rapidly becoming deforested and eroded. He knew he had to act quickly.

You would be a young adult by now, your life perhaps already affected by Rogers's influence on local affairs. He had been instrumental in moving the

Lanterman's Falls and the gorge at Mill Creek Park. *Courtesy of Historic Images.*

county seat from Canfield to Youngstown, and in two terms as city solicitor, he had organized a hodgepodge of laws into an orderly municipal code. Now he was ready to use his legal skills to establish a free public park.

Using his own money, Rogers quietly began buying options on land along Mill Creek. Then he drafted legislation that would create a township park district, a board to supervise it and the legal means to raise funds and acquire and preserve property. The following year, Rogers was appointed to the new park district board of commissioners, a position he would hold for the rest of his life.

Now Rogers's years of independent study in landscape architecture and natural history could be put to practical use. He sought the advice of Frederick Law Olmsted, the foremost landscape architect of that time, who was impressed by Mill Creek's natural features. Olmsted advised that roads and other constructions be kept to a minimum, used only to make the natural beauty of the setting more accessible.

As construction got underway, Rogers showed a genius for thrift, using stone and other building materials found in the gorge itself. If you had been

The stone parapet bridge near the Falls Avenue entrance of Mill Creek Park in 1912. *Courtesy of Historic Images.*

a young man in 1893, you might have worked there yourself. That year, a severe economic crisis led to a public works project to provide employment while improving the park. This kept skilled workers from moving away, something that would benefit Youngstown's future growth and economy.

But in the 1890s, Mill Creek's recent past had left much environmental damage to repair. Rogers brought in red squirrels from Pennsylvania and ordered trees and shrubs from all over the eastern United States. He planted thousands of trees himself, and not a tree could be cut or pruned without his personal supervision.

Once the park was ready for visitors, there was a problem getting visitors to the park. Rogers then turned his attention to public transportation. In doing so, the entire South Side of Youngstown opened up to development. Scores of people moved to new houses there, leaving the crowded city for a more healthful environment.

Youngstown still had water problems and local government once proposed turning Mill Creek into a reservoir. But Rogers fought that proposal for seven years and won. Youngstown found other ways to maintain a safe water supply, and the city and the park grew and prospered together in the early years of the new century.

A group of picnickers in Youngstown's Mill Creek Park, circa 1912. *Courtesy of Historic Images.*

Rogers would have been a familiar sight in those days, taking daily walks in his trademark long overcoat, umbrella and bowler hat. If he saw you carelessly drop a piece of litter, he might scold you, but his greatest desire was for people to enjoy nature. Once, when he caught some boys killing birds, he responded by showing them Audubon charts and making bird lovers of them.

Rogers advised parents to play with their children in the park, teaching them about nature—that doing so would plant seeds of something "ennobling" in them. It's refreshing to hope that today children playing in Mill Creek Park might be catching something of Rogers's sense of public service.

Thanks to the expanded facilities of Mill Creek Metropolitan Park District, more children than ever are reading from Rogers's "great book of Nature."

Park naturalist Ray Novotny believes that Rogers would be especially pleased that one thousand additional acres south of the original park have been preserved, saving a bit of wilderness in the midst of our rapidly growing suburbs.

Volney Rogers, founder of Mill Creek Park and a dreamer with a host of practical skills, died of influenza in 1919. Schoolchildren contributed pennies to a fund for his statue, the city's only statue of a prominent citizen.

By 1922, Volney Rogers Field was opened. You might have enjoyed ballgames there with your grandchildren. Today, those grandchildren have grandchildren of their own who can thank Volney Rogers for much that is good in our community. Especially Mill Creek Park.

CRYING FOWL AND LOOKING FOR CLUES: THE CANFIELD FAIR ROOSTER TURNS UP MISSING

Mark C. Peyko

Who would steal an eight-foot-tall Fiberglas rooster? And where could you possibly hide an object as large and familiar as the Canfield Fair's towering mascot?

That's what Canfield Fair officials probably were wondering in the fall of 1975 when the fair's trademark—but unofficial—mascot was snatched from its perch on the roof of the Sound Tower.

Soon, the Canfield Fair board was crying fowl and looking for clues.

Consider the challenge. The rooster was securely fastened to the roof of the Sound Tower at the grandstand. The perpetrators first had to remove rusted anchoring bolts before the towering eight-foot chicken could be spirited away. And since the object weighed over one hundred pounds, the act was probably the work of more than one person.

However, then came the central questions: what do you do with such a large, unwieldy object after you take it? Where would you hide it?

The 1975 theft was reported in an early November issue of *Farm and Dairy*, a weekly agricultural newspaper based in Salem, Ohio.

Because the theft occurred so close to Halloween, it might seem that the rooster was the victim of a prank. However, Paul Moracco, grounds superintendent at the fairgrounds, said the theft had been part of a prank between rival high school football teams at Poland and Canfield. Moracco said that Poland's football players were set up to look like they had taken the mascot, when in fact it had been members of the opposing team.

Moracco recalled that frosty November morning in 1975, close to Thanksgiving, when the purloined mascot was found—unharmed—chained to a flagpole at Canfield High School. While representatives from the fair declined to say as much on the record, the rooster's reemergence reportedly followed the payment of a $100 ransom.

Although no one was ever prosecuted in the theft, the rooster is now removed and stored after the annual fair to prevent theft and prolong the rooster's life.

The rooster, and the catchphrase "Something to crow about," has a long association with the Canfield Fair, but it was only in 1989 that the familiar mascot became an official trademark of the fair.

In a 1992 interview, June Burgoyne, a secretary at the fairgrounds, said that the rooster was first discovered at a 1968 convention in Chicago. She said that Grace Williams, a longtime fair organizer and employee, saw the eight-foot Fiberglas fowl and notified the fair board.

After some discussion, the fair board acquired the rooster. It soon became an icon and landmark at the fairgrounds.

LAST RIDE AT IDORA PARK

Ron Flaviano

Many people from the Mahoning Valley and surrounding areas have fond memories of Youngstown's Idora Park, which closed in 1984. Tucked away in a neighborhood on the South Side of the city, Idora almost seemed like a hidden treasure. No matter how many times I would drive through Mill Creek Park, it was always a surprise to see the framework of roller coasters looming above the trees, like sentinels watching over the long-forgotten amusement park.

I spent many summer days at Idora Park with my family during childhood. My dad was an electrician at American Welding [AmWeld] in Niles, and it held its annual company picnics at Idora Park. For Idora, and many small amusement parks in middle America, company picnics were a great source of income.

For my family and me, it was a great source of fun. My sister, cousins and I looked forward to it every year. Unlike Cedar Point or Geauga Lake, Idora Park wasn't a large sprawling affair, just roughly thirty acres of fun and games. You didn't have to drive very far to get there either, although it seemed like it took forever as a child.

Because it was such a compact amusement park, Idora always felt very comfortable. You never worried much about finding your parents when you were out on the midway or enjoying the rides. You always felt that they were nearby, either in the picnic area or maybe enjoying some of the famous Idora fries doused with vinegar and salt. Since the park was very affordable, we often went in addition to the AmWeld picnics. Sometimes we were lucky enough to get Ridora tickets, which let you ride everything all day long.

I have many vivid memories of Idora Park: the weird smell on the inside of the Lost River ride; the air whizzing past as we whirled on the Rocket

Ride; climbing the stone steps to the picnic areas; the talking garbage cans; the incessant buzzing of the canopy-covered rides in Kiddieland; and the floating neon ceiling of the ballroom.

One trip from the late 1970s was full of memorable mishaps. The first incident was on the bumper cars. We all loved the excitement of bashing into each other and the electrically charged, sulfur smell of the ride. My cousins, my sister and I waited patiently as each group in front of us got their chance to drive like maniacs. After about ten minutes, which in Idora time was a long wait, it was our turn. As we scrambled into our cars with the rest of the crowd, we waited for the sparks to fly above us that allowed us to drive.

Well, I've had the fun of wearing glasses since the second grade, and they've always presented an issue on rides. The dilemma: take them off (and not see anything) and drive really crazy, or wear them and risk my spectacles falling off during the ride. This time, I chanced it. No sooner had the ride started when my cousin, Janene, smashed into me. That sent my glasses flying onto the dirty floor, in danger of being crushed by another car!

Without a second thought, I popped out of my car and started crawling around, trying to save my glasses. I found them just in the nick of time. Only one of the stems was bent, as they only had been half run over. The ride operator, shocked to see someone out of a car and on the floor, immediately shut off the ride. He then made everyone leave. He shouted that I wasn't supposed to be out there, and I told him that my glasses flew off. Many profanities were murmured after everyone had to get back in line for the ride.

I was particularly fond of the Jack Rabbit roller coaster. Although it was much tamer than the Wild Cat, the Jack Rabbit packed a punch. There was little holding you in the Jack Rabbit's car—just a worn leather strap and a little hook-latch that was usually sprung. As you rounded the big curve at the top, it wasn't surprising to see little pieces of black stuff, like shingles, falling to the ground. I was never sure what that was, but it didn't seem to affect the safety of the ride. The Jack Rabbit's hills and dips made you fly out of your seat, so you definitely had to hold on! The ride's orange and turquoise paint is still fresh in my mind.

It was after one of our many rides on the Jack Rabbit that afternoon that my parents announced that it was time to head home. We begged and pleaded for just one more ride. Because the Spider was near the exit, that would be the one. The Spider, with its tentacle-like arms and two sets of cars spinning wildly, was always a favorite. However, that day the ride was an extended version. We all boarded the ride expecting it be our last two-

minute spin before going home, but we were wrong. After the spinning and lifting started, the ride operator must have gone on a cigarette break. We were on that ride for a good ten minutes or more; finally everyone started yelling and hollering to be let off. We weren't in any danger, just dizzy and nauseated. (I remember my cousin Robbie had sipped too much of a blue slush drink just before the ride.) Still, we went back to Idora Park many more times after that eventful Saturday.

My memories of Idora Park are not unique. Tens of thousands of Mahoning Valley residents enjoyed the amusement park over its eighty-five-year existence. Sometimes referred to as Youngstown's Million-Dollar Playground," Idora Park began as Terminal Park in 1899. The park and its picnic grounds were located at the end of a trolley line on Youngstown's South Side. It had become commonplace for amusement parks to spring up at the end of trolley lines to spur real estate development. Eventually, after a naming contest was held, the park was called Idora Park before the 1890 season. Initially, the attractions were pretty basic—a bandstand, dance pavilion, swing ride and concessions stands.

As the years went by, Idora developed into a park with many rides and attractions, including one of the nation's top ten best wooden roller coasters, the Wild Cat. Picnics were held there each summer for dozens of local factories and businesses. It was like a hidden getaway from the mills and city streets. Beautiful landscaping and flowers added color and vibrancy to the park. The Idora Park Ballroom was one of the largest in the nation and hosted many famous acts over its history. The Glenn Miller and Tommy Dorsey Orchestras played Idora, as did many other popular acts. Idora was indeed a very special place. Even after similar parks closed throughout the nation, Idora managed to keep on going. However, when Youngstown's steel mills began shutting down in the late 1970s, it hurt the park because company picnics were Idora's bread and butter.

But lack of attendance didn't silence the carousel music or stop the park's coasters in their tracks. A tragic fire in the spring of 1984 ultimately spelled Idora's demise. While workers were doing repairs on the Lost River, a work torch ignited some of the dark ride's interior decorations. Although park employees and over ten fire companies battled to save the amusement park's endangered attractions, the dry wooden structures burned easily. After the blaze had been put out, the Lost River, park offices, several concession stands and a portion of the legendary Wild Cat roller coaster had been destroyed.

The park's owners decided that it would be cost prohibitive to rebuild the Wild Cat but managed to open for the 1984 summer season. However, visitors knew that the end was near. Even though the carousel and other

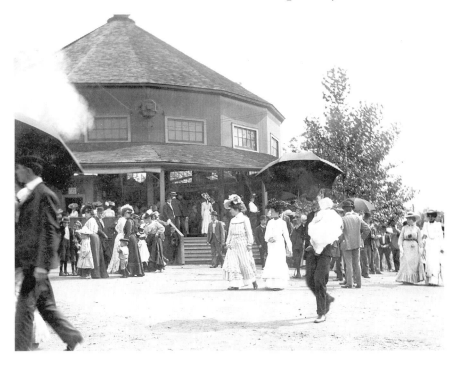

A turn-of-the-century scene at Idora Park. The original carousel barn is seen in the background. *Courtesy of Historic Images.*

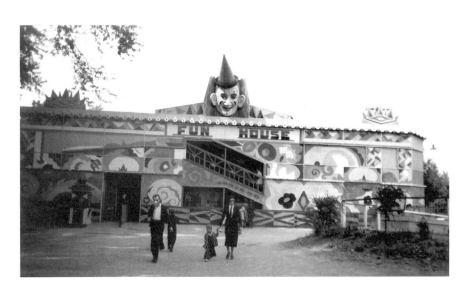

The fun house at Idora Park on May 22, 1938. *Courtesy of Historic Images.*

A rare image of the Idora Park carousel printed from an obscure collection of photo negatives. *Courtesy of Historic Images.*

attractions had been spared, the heart of Idora—the Wild Cat—was gone. Plastic pennants (similar to those seen at car lots) roped off the coaster, but its charred remains were within view of patrons. It was a very sad time.

At the end of the season, the park's owners decided that Idora would close, as no one had shown interest in buying the park. The main rides including the carousel and many of the park's other items were sold at an auction in the fall of 1984. Youngstown's Million-Dollar Playground was no more.

I was a sophomore in high school at the time and was deeply saddened over the situation, as were countless residents of the Mahoning Valley. There was a little bit of hope that the park may be reborn in some way, as a local church had purchased it. But that hope faded as the years went by and Idora's buildings fell victim to mysterious fires.

By 1992, my friend Ann and I were completely disgusted over the situation at Idora. We had watched Idora decay further and witnessed a group's failed attempt to buy and restore the park. Ann had grown up on the North Side of Youngstown and spent many summer days at Idora. We had become friends in college, and after graduation we ended up working together for a few years. It was during that time that we decided to see what we could do to help our long lost park.

Idora was never really secured that well after it closed, so it was easy to sneak in and visit our old friend. We visited the park several times over 1992 and 1993. We wanted to photograph and videotape the park to somehow freeze it in our memories. Even though most of the attractions were gone and many of the buildings had burned, it was still Idora. The hulking ruin of the Wild Cat still roared out of the treetops, and most of it was intact. However, at the end of one of its precarious dips, the charred frame of the coaster was abruptly cut off. The coaster's boarding platform and housing

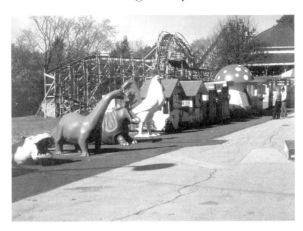

Lined up and ready for sale—the 1984 auction at Idora Park. *Courtesy of Historic Images.*

was all intact, as was the Jack Rabbit, Kiddieland and the carousel barn. Weeds had sprung up throughout many of the blacktop paths, but the park was still identifiable. If you stood in certain sections of the park, where the damage couldn't be seen, it appeared as if nothing was wrong. Sometimes it felt like at any given moment hundreds of school kids would be rushing in to line up for the rides.

Although it was sobering and quite sad to see Idora in this state, it also was like returning to a childhood playground. While there, we felt like we owned the park. We were the only two people there, going from one building to the next, taking pictures of everything. Filled with childlike enthusiasm, we ran to the Jack Rabbit and climbed onto the platform, gingerly stepping over broken and decayed floorboards. Both of us took turns with the coaster brake handle, pretending that we were letting park patrons off the ride. We did the same on the Wild Cat platform. There we heard something that really surprised us. Although there was music blaring from a radio nearby (Idora was located in the middle of a residential neighborhood), we both could distinctly hear something like carousel music. Not pronounced or completely clear, but almost as if it were part of the wind. Neither of us mentioned it until we left the park, but we were shocked to learn we had heard the same thing. It was like the spirit of Idora Park was trying to say hello to us for taking the time to stop by. We took hundreds of photos that day, including some inside the ballroom.

Our last visit to Idora Park was one of the most harrowing. Ann and I had decided that we were going to try to shoot some dramatic video inside the park as part of a mystery movie we were trying to make. I parked my car at the end of the street entrance to the park, and we climbed over the turnstile to get in. This time was a little different, as we felt a bit like cat burglars.

While deep inside the park, we saw two police officers investigating my car. Scared that we had been caught trespassing, we hid inside the Hooterville Highway tunnel until they left. All that was running through my mind was that they were going to tow my car away!

Since we thought we were going to be escorted out of the park at any moment, we decided to discretely climb into the ballroom to see it again. The same ballroom window had afforded us entry in the past, and it was out of sight of the police officers. We explored as much as we could inside and took many photographs. We lifted an incredibly heavy cash register up onto the ballroom's bar to get a better view of it, and we discovered an entire room filled with Idora Park wooden folding chairs. We noticed that the "I Want Idora Back" signs that we had posted earlier all over the ballroom had been removed, so someone had been there recently. There was a huge copier in several pieces strewn next to the bar, and boxes of papers were everywhere. Water had damaged many portions of the beautiful ballroom ceiling, in turn damaging the hardwood floor below.

The coatroom was intact and still had hundreds of hooks for the ballroom dancers' wraps and overcoats. The bathrooms had been vandalized over the years, and many of the fixtures were either gone or broken. Even in its state of disrepair, the ballroom still had a sense of grandeur. You could almost imagine dancers gliding across the floor to big-band music. Then Ann discovered the ballroom's breaker box. Could it be that there was still power in the building? With each switch that she flipped, pools of multicolored neon lights filled what was left of the floating ceiling. It was pure magic. Nearly every light was on, and the ballroom was transformed from a dark, decaying, abandoned building to a promising fixer-upper. The stage, which had been home to bands ranging from Glenn Miller to the Monkees, was bathed in light, its tattered curtains hanging up above. A lonely grand piano sat in the middle of the dance floor, hopelessly out of tune but stately nonetheless. We were astonished that the building had any power at all, since it had not been used for many years. We took advantage of all the beautiful lighting and photographed and videotaped the interior extensively. It was like we sensed that this was the last time we would see this place, and we wanted to capture what we could.

After about an hour of exploration and illumination, we turned all the lights off and left everything as we found it. Later, we both wished that we could have been able to take one or two of the wooden Idora chairs, but we didn't want to chance being arrested. As we hoisted ourselves over the turnstile and made it back to the car, we realized that our last ride at Idora was an adventurous one indeed.

A forlorn piano in the Idora Park ballroom in the early 1990s. *Courtesy of Ron Flaviano.*

SCHWEBEL'S GIANT: MATRIARCH PROVED TO BE KEY INGREDIENT IN YOUNGSTOWN BAKERY'S SUCCESS

Rebecca Dale

When families in the Mahoning Valley gather to tell stories, chances are good that they will be immigrant stories. For Youngstown is a city of immigrants, people who followed their dreams to a new land. The story of the Schwebel family and the bakery that they built over a century ago is one such story.

Joseph Schwebel, a young baker from Poland, arrived in America in 1898 and first worked as an apprentice for Ozersky Brothers, an early Youngstown bakery. Before long, he and his brother, Morris, tried to start a bakery of their own. However, it wasn't until Joseph married Dora Goldberg in 1906 that the Schwebel Baking Company really began.

According to their son, David Schwebel, Dora—a Polish immigrant herself and only nineteen years old—told her new husband, "If you're going to have a partner, I'll be your partner." And so she was. Indeed, if any one person can be credited with Schwebel's success, it would be this remarkable woman. As David Schwebel explained, "Dad was the baker. Mother was quite a businesswoman. She taught us a lot."

The couple began baking bread in the kitchen of their Campbell home. Dora Schwebel packed the loaves, forty pounds at a time, in a wicker laundry basket and delivered them on foot to the boardinghouses where immigrant steelworkers lived.

The following year, the first of their six children was born. The year after that, they moved to a building on Center Street in the Haselton area.

The new quarters had a coal-fired brick oven, a small retail store in the front and living quarters above. They added pumpernickel and Italian bread, hard rolls, cakes, pies and cupcakes. They hired their first driver-salesman and began delivery by horse and wagon, selling their baked goods door to door and in small stores, as well.

Joseph and Dora Schwebel bought more property in Youngstown and, in 1923, built a small bakery on West Lawrence Avenue. By this time, they were baking one thousand loaves a day and had fifteen employees. Everyone worked, including the children after school. "Dad gave me a quarter for sweeping the floor," David Schwebel recalled. "Each one of us had a job. My mother was there and she was the boss."

The bakery grew as the Schwebel children grew. "We learned from the bottom up, not the top down. We followed one another right up the ladder," said David Schwebel. His brother, Samuel, became a doctor while his other brothers and sisters—Sadie, Frances, Irving and Elaine, along with David—took their places in the business. Yes, the girls, too. Frances Schwebel Solomon served for many years as chairman of the board. And why not? They all had their mother as a role model.

Joseph Schwebel died in 1928. Then, in 1929, the stock market crash ushered in the Great Depression. No one had expected a widow with six children to hold a company together under such difficult circumstances, but Dora Schwebel was equal to the challenge. She was so well respected that flour companies extended credit to Schwebel's when they were demanding cash from other bakeries. And "Happy the Clown" became the company's symbol in the midst of the Great Depression. The business was expanding and the future looked good.

David Schwebel remembered that in those early years "all the bread was made by hand. There were thirty or forty fellows standing around a bench cutting it, proofing [raising] it, rounding it into loaves and baking it in the old brick ovens." Then pan breads came in, and baking became more automated. Sliced breads became available in the mid-1930s.

During the war years, Schwebel's concentrated mainly on baking bread for military needs, but economic expansion after the war created pressure to move to bigger quarters. The answer was a $1 million bakery on Midlothian

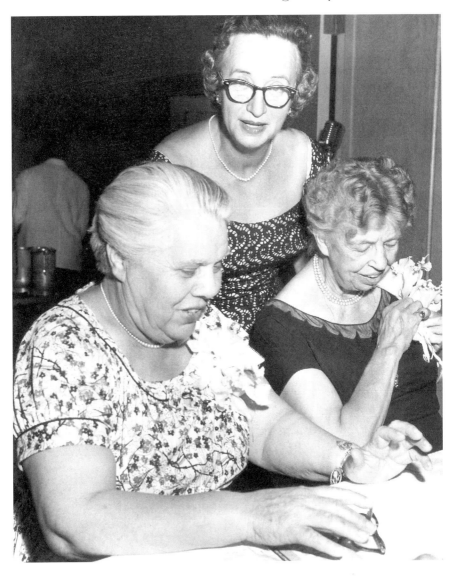

Dora Schwebel, president of the Schwebel Baking Company, seated next to former first lady Eleanor Roosevelt at a Youngstown function in the mid-1950s. *Courtesy of the Schwebel Baking Company.*

Boulevard, built in 1951, followed by millions of dollars in expansions over the years. Since 1996, the company has invested more than $5 million in renovations and expansions.

In addition to that building, Schwebel's has plants in three other Ohio cities: Cuyahoga Falls, Solon and Hebron. Its 1,400 employees turn out 600,000

loaves a day to be delivered to supermarkets across Ohio, Pennsylvania, New York and West Virginia.

Schwebel's continues to be family owned and operated, one of the few independents left in the United States. The third generation is at the helm now, and Lee Schwebel, who joined the company in 1995 as consumer affairs director, is the first member of the fourth generation to take his place in this tradition. He serves as director of corporate communications for the company. Other fourth-generation family members include Adam Schwebel, Maryn Schwebel and Jana Schwebel.

Yet, as large as the company has grown, they "still make bread the old fashioned way—in two stages," according to Lee Schwebel. This means the dough rises twice first as a "sponge" mixture of flour and yeast, and then other ingredients are added depending on the type of bread and it rises again as loaves.

Old-fashioned as the technique may be, it's carried out in the most modern, automated and spotless of environments. And the many kinds of bread offered have been developed with modern nutritional goals in mind. They have baked "Roman Meal" bread for a number of years and more recently created "Schwebel's Selects," a line of whole grain breads.

Over a century of pride is evident at Schwebel's headquarters on Youngstown's South Side. Scores of pictures and plaques line the walls, attesting to the company's and the family's involvement in the community. And Dora's pictures and achievements are prominent among them. Because as Lee Schwebel said, "It's really her legacy. It's all about carrying on that legacy—generation to generation. It's the American dream personified."

Visit us at
www.historypress.net